IMAGES OF ENGLAND

# THE WIGSTONS

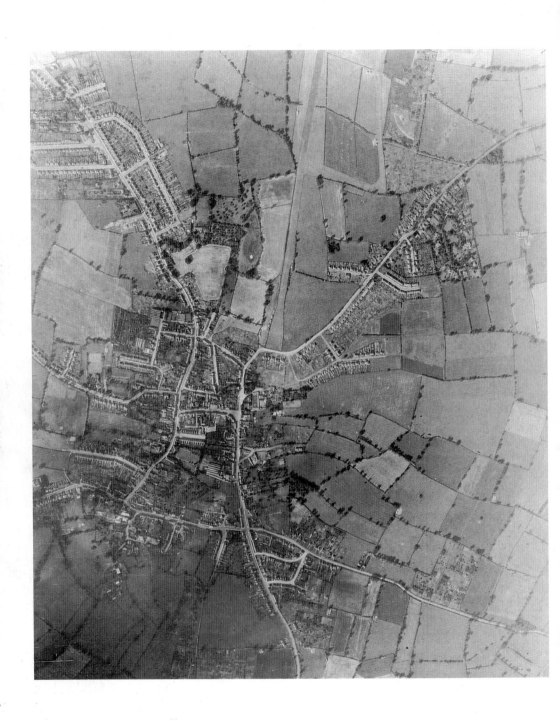

IMAGES OF ENGLAND

# THE WIGSTONS

DUNCAN LUCAS AND TRICIA BERRY

TEMPUS

*Frontispiece:* This aerial view of Wigston Magna was taken on 19 August 1945 and shows the area before large-scale development changed the landscape for ever. Mere Road was taking shape and housing was already established on both sides of the Welford Road at Wigston Fields but otherwise the village probably looked much as it had for many years previously.

First published 2005

Tempus Publishing Limited
The Mill, Brimscombe Port,
Stroud, Gloucestershire, GL5 2QG
www.tempus-publishing.com

© Duncan Lucas and Tricia Berry, 2005

The right of Duncan Lucas and Tricia Berry to be identified as the Authors of this work has been asserted in accordance with the Copyrights, Designs and Patents Act 1988.

British Library Cataloguing in Publication Data.
A catalogue record for this book is available from the British Library.

ISBN 0 7524 3673 2

Typesetting and origination by Tempus Publishing Limited.
Printed in Great Britain.

# Contents

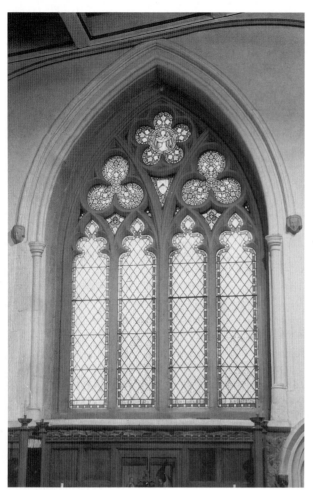

*Left:* Stained-glass window in All Saints Church donated in memory of George Davenport MA (1631–1677). Born in Wigston to a distinguished family who lived at Moat House, a long-gone moated manor house to the south of Moat Street, he trained for the Church and became Rector of Houghton-le-Spring, near Durham. In 1661 he replaced the All Saints communion plate which had disappeared during the interregnum. The silver cup displays the Davenport Coat of Arms and the paten is inscribed *Ecclesiae de Wigston dedit Georgius Davenport, Clericus, natus ibid*, which translates as 'Dedicated to the congregation of Wigston by George Davenport, priest, native of that place'.

*Below:* This map is taken from a sales leaflet produced by W. & G. Clarke, wheelwrights, *c.* 1908. Their workshop was at 103 Leicester Road and later a house was added to the site. The family had been wheelwrights for at least five generations. The map shows some names which have fallen out of use, such as Apple Pie Corner, at the junction of Spa Lane and Mowsley End, and Frog Alley, off Moat Street.

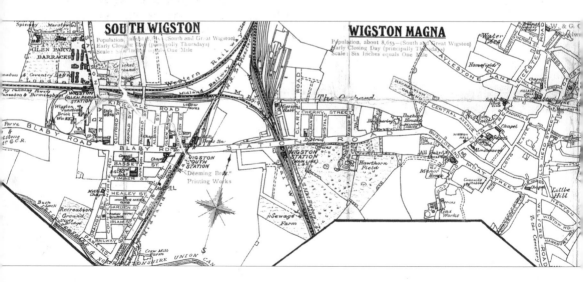

# Acknowledgements

The authors would like to extend their most grateful thanks to their many friends and acquaintances, too numerous to name, who have willingly supplied photographs and assisted with information for this book. To the staff at the Leicester, Leicestershire and Rutland Record Office for their help and attention, and to Neville Chadwick for photographic work.

Additionally, thanks to the following for permission to use material:

- English Heritage – Page 2.
- E.J. Morten Publishers – Page 29 (top). This image is from an engraving by Rajon of a portrait by W. Ouless, RA, exhibited at the Royal Academy under the title 'The Chemist'. The experiment shown is the process patented by Mr H.D. Pochin for the clarification of rosin.
- Ward Collection – Page 33 (top).
- D.S. Hunt – Page 35 (top).
- Harvey Ingram Owston – Page 36 (top).
- National Portrait Gallery, London – Page 38 (top).
- Record Office for Leicester, Leicestershire and Rutland – Pages 34 (top), 38 (bottom), 50 (bottom), 116 (bottom) and 119 (bottom).

# Introduction

It is eight years since the authors compiled *Wigston Magna and South* for Chalford Publishing and it gives us great pleasure to have the opportunity to produce a similar book for Tempus. Last time we shared the task with Peter Mastin, whose untimely death the following year robbed us of a good friend and a hardworking, talented colleague. It also robbed Wigston of a knowledgeable, energetic historian. We have missed him greatly, particularly over the last few months as work on this book has progressed.

The book's title has been chosen to embrace the various areas of our township of Wigston Magna, South, Fields, Harcourt and East. Duplication of material from earlier publications has been kept to a minimum, but in a few cases this has occurred in order to maintain the themes chosen. Some modern photographs have also been added where relevant or if nothing older was available.

It is hoped that this book will give as much pleasure and interest to others as it has to us in compiling it. Any profits generated will go to the Framework Knitters Museum to further the work of preserving this unique reminder of Wigston's past.

one

# Street Scenes

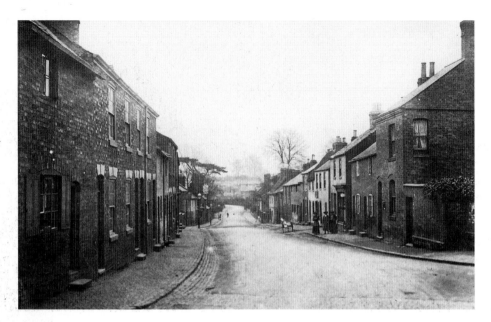

Moat Street looking towards the crossroads with Newgate End leading off to the right, *c*. 1907.
Note that the road retains its cobbled surface in the foreground. The houses on the left have now
gone except for the pair with the lower roofline which have been converted into one dwelling
known as Cromwell Cottage. The cedar tree in the middle distance marks the front garden of The
Cedars. Most of the buildings on the right remain.

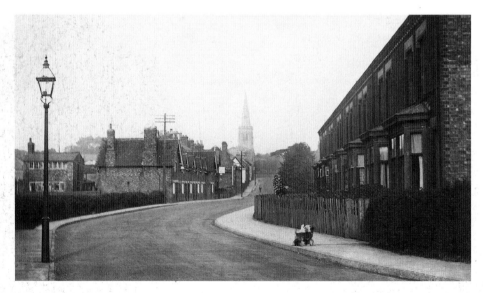

The same street in 1920 from the opposite direction, showing on the left the distinctive London
or Moat Cottages. These were built by H.D. Davenport in 1850 near the site of his family's ancient
moated home, from which feature the street took its name. They have now gone, as has the typical
framework knitters' workshop to the rear. On the right the colloquially known Peacock Row does
survive, while on the pavement two dogs play.

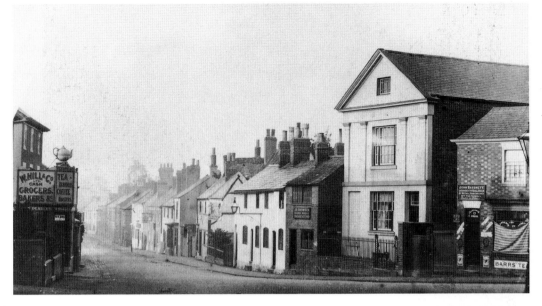

Bull Head Street taken from the Bank, *c.* 1910. Prominent on the right is the tall Snowden family house and needle-making workshop, while lower down are Laundon's Saddlery shop and the old Quaker Cottage. On the left, very prominent, is the shop of W. Hill & Co. Ltd, who traded as grocers, bakers, tea blenders and coffee roasters. The huge teapot on the roof of the extension certainly catches the eye. This three-storey building survives but minus its extension.

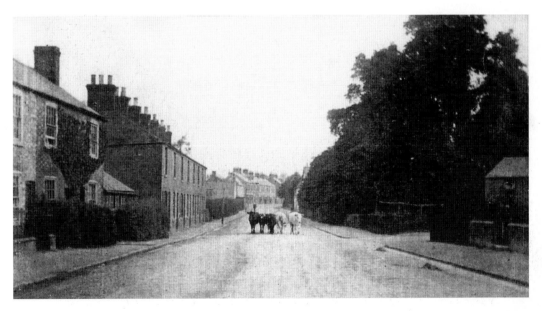

Bull Head Street looking the other way, *c.* 1903. A farmer, following at some distance, walks five young beasts to new pasture in this peaceful scene. All the buildings here have since been demolished for road widening. The entrance on the right leading to the Horse and Trumpet public house is the only feature which remains.

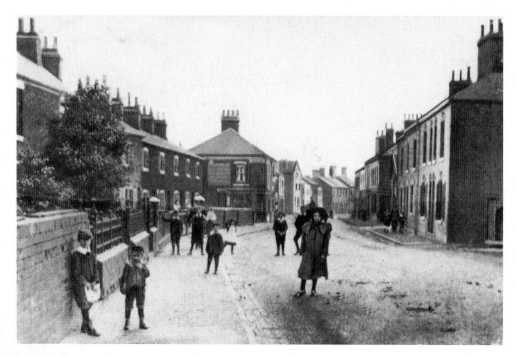

Leicester Road taken from in front of the Star and Garter public house looking towards Wigston centre, *c.* 1910. Burgess Street is to the left in the middle distance and opposite, on the right, is Victoria Street. Not a single building in this view survives today.

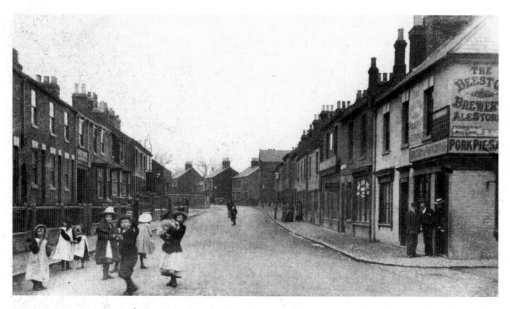

Leicester Road taken closer to the centre and facing outwards, *c.* 1904. The gateway on the left and premises beyond belong to Samuel B. Matthews (see page 32). The road to the right is Frederick Street, the sign adding that this was lately known as Mill Lane. The corner property is a beer retailer and grocer while further along a sign states that this building is a Midland Railway parcel receiving office.

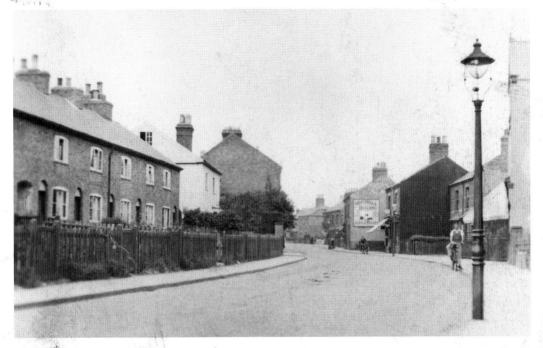

Another Leicester Road photograph taken in the 1930s. The building in the distance has a large sign advertising that Mitchells and Butlers ales and stouts are sold there. Further on a house stands on the site of the present Bishop & Bishop's Garage.

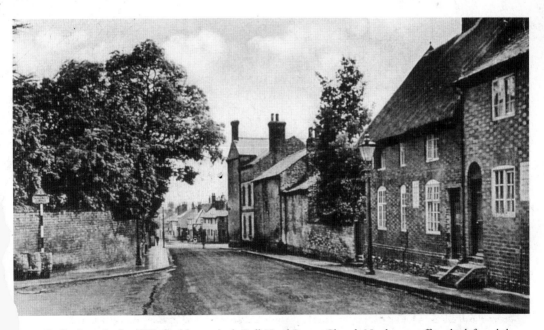

Oadby Lane in the 1930s looking towards Bull Head Street. Church Nook goes off to the left and the wall on the corner belongs to St Wolstan's House. The name has always been retained despite the nearby church name having reverted to its original dedication in the 1950s.

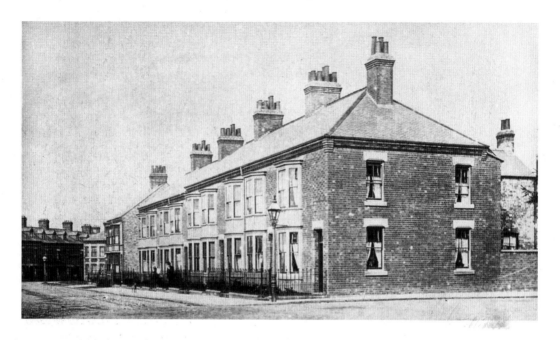

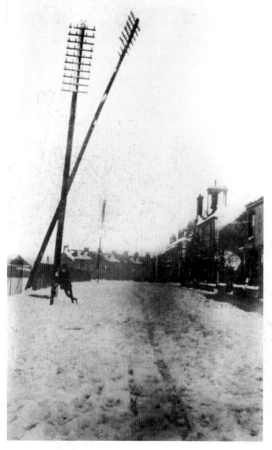

*Above:* Railway Street with Countesthorpe Road on the right, *c.* 1908. The three-storey houses in Park Road just visible in the distance have now been replaced by an industrial unit occupied by Pegasus Displays.

*Left:* Another view of Railway Street taken at a similar date and some 25 yards further back, from a section now renamed as a continuation of Countesthorpe Road. Plenty of snow on the ground this time and also strong winds judging by the fate of the telegraph pole. The man 'holding up' the other pole is not the only person shown, just visible between the two poles is someone standing on a shed roof, most probably repairing more storm damage! A row of houses now occupy the open land to the left.

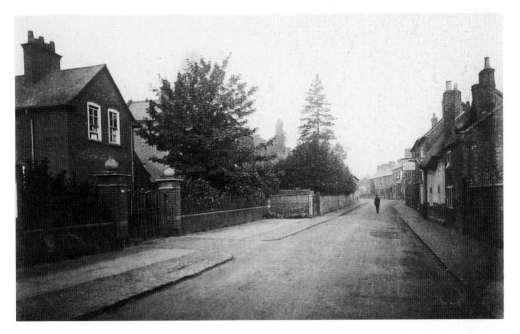

Bushloe End in the 1920s. On the left is the vicarage and behind the trees is The Elms. To the right the Plough Inn sign can be seen with the hosiery workshop premises (now the Framework Knitters Museum) beyond. The wall belonged to Kingswood Lodge.

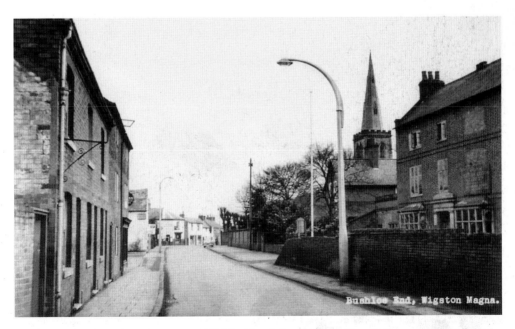

Bushloe End looking the other way, *c.* 1958. The Elms is in a poor state but has been acquired by the British Legion and is soon to be rebuilt, though retaining the original façade. On the left the gap is the Plough Inn car park, the pub having been rebuilt further back from the road.

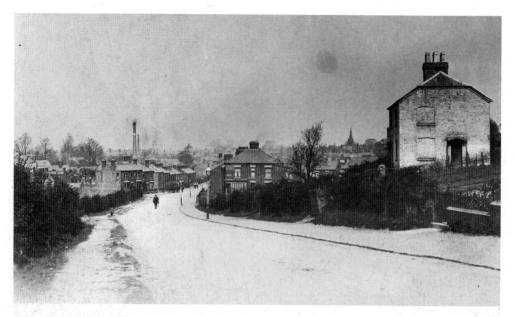

Welford Road looking down over the village, *c.* 1913. The laundry chimney and another belonging to one of the hosiery companies are visible in the distance as is St Wolstan's Church. Harcourt House at the crossroads can be still recognised as can the shop premises on the corner of Wistow Road.

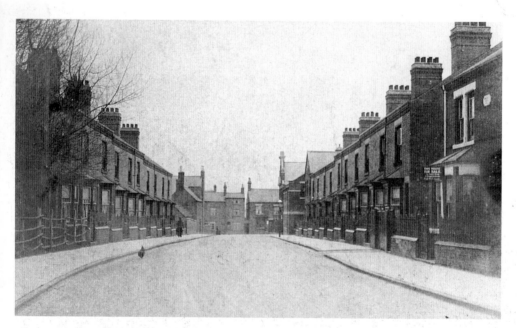

Central Avenue looking towards Long Street, *c.* 1918. The Wigston Co-operative Society purchased this land in 1896 and laid out the avenue. They erected ten houses on each side which they retained as an investment and sold the rest as plots to their members. In 1910 they had also built their impressive headquarters just visible on the right-hand corner with Long Street.

Central Avenue looking the other way, *c.* 1918. In the distance a fence can be seen marking the start of open countryside. The driveway to the right leads to some workshops currently occupied by Harry Hall (Engraver) Ltd and M. & S. Precision Engineers, toolmakers.

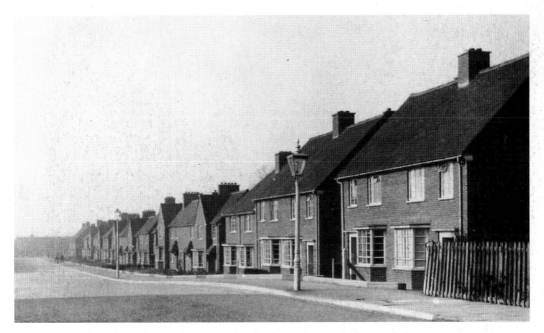

Central Avenue in the 1950s showing the countryside now opened up and developed with council housing, all looking rather new, and not a car in sight.

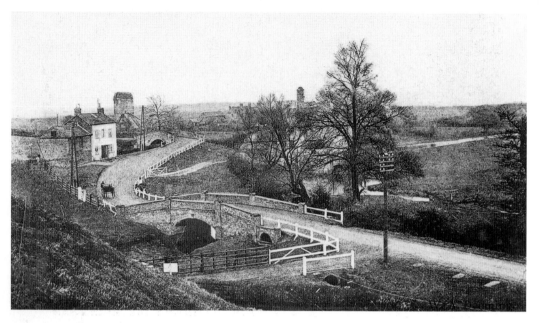

Crow Mills giving a clear view of the two bridges and surrounding area, *c.* 1913. In the distance to the left is the windmill and white house which have long been demolished. In the centre behind the trees the watermill chimney is visible.

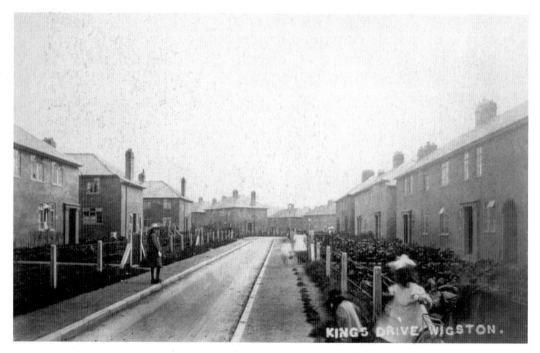

Kings Drive in the 1920s showing an early example of the modern housing development. Note the narrow road with planners having no idea of how car ownership would take off.

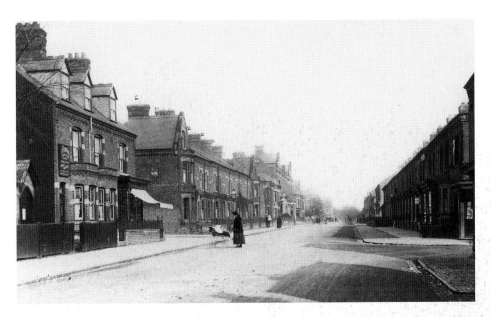

Blaby Road looking east, *c.* 1903. On the left the notice on the first house advertises the services of F.C. Biggs the plumber, while the shop on the corner of Clifford Street is the Wigston Drug Store whose proprietor is William A. Holmes. The turrets in the distance belong to the Clarence Hotel. Countesthorpe Road runs off to the right.

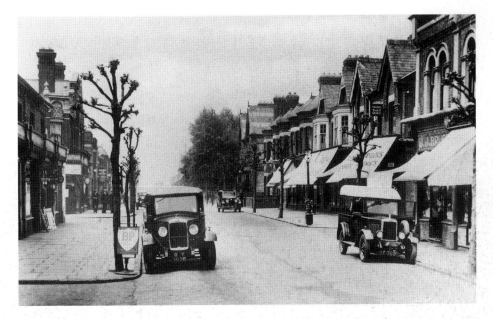

Blaby Road again and this 1930s view looking the other way has a more cluttered look with motor cars, lamp posts, trees and shop blinds taking up space. The shop on the right is J.J. Bruce the pawnbroker, this building is now occupied by the Helping Hands Centre. The next building houses Taylors the chemists, which is now run by Gordon Davis. To the centre left on the corner of Canal Street is Charles Moore's Music Shop, which is now Moonlit, another chemist. Just off the picture on the front left is Huddleston's Garage.

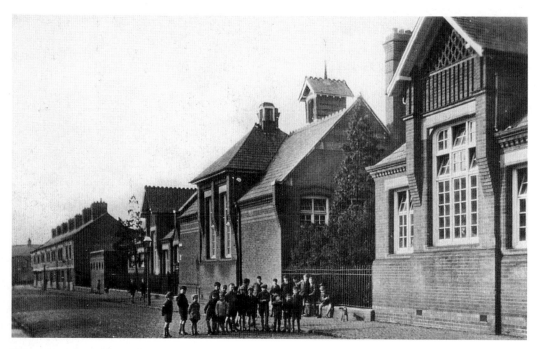

Bassett Street in the 1920s showing the three schools. Two have been demolished but the one on the right is now used as the highly successful Bassett Community Centre. The row of houses remain and Canal Street is just visible in the distance.

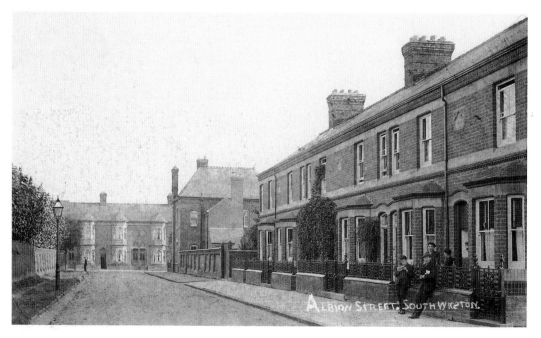

Albion Street (*c.* 1908) with a family posing outside No. 13 and Blaby Road just visible in the distance. The house on the corner on the right is the Limes, home of Herbert Simpson, solicitor, while the garden wall on the left corner belongs to Orson Wright's home, Ashbourne House.

24

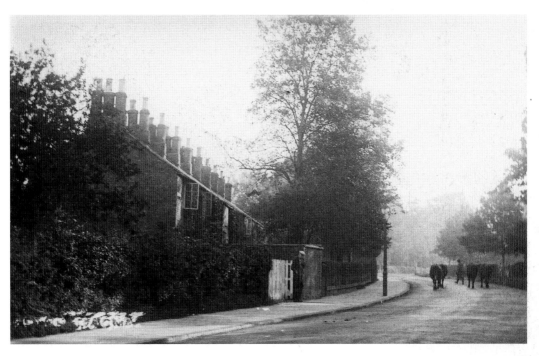

Station Road in the 1920s with cattle being walked towards Wigston, perhaps having been bought at the cattle market and collected from the station. The cottages on the left known locally as Ten Row have now been replaced by the South Leicestershire College of Further Education.

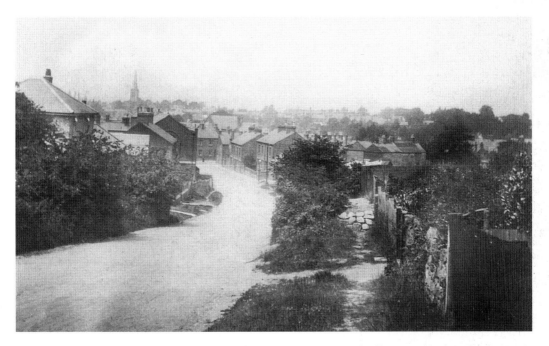

Newton Lane in the early 1930s looking towards the crossroads with All Saints Church in the distance. W. Holmes' hosiery factory is at the bottom of the hill on the left (now operated by Europa) and development up the hill appears to be established, but note there are no footpaths.

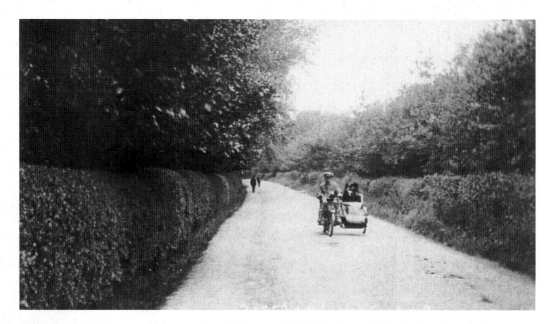

Saffron Lane showing an early motorcycle and sidecar, *c.* 1913. This view is believed to have been taken looking away from South Wigston, just past the entrance to the Leicestershire Regiment's barracks. The present turning for Gloucester Crescent is in the distance just about where the first figure is positioned.

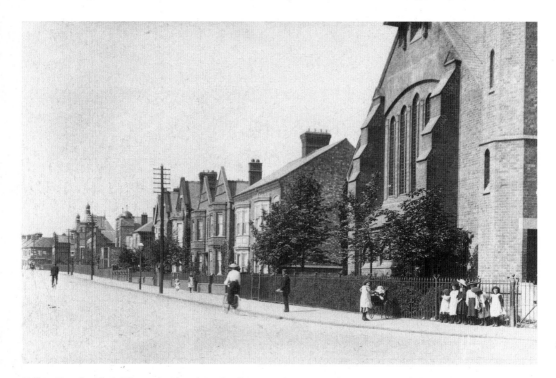

Saffron Road with St Thomas's Church in the foreground, *c.* 1906. The twin towers belong to Toone & Black, a large boot and shoe company run by Benjamin Toone and John Wycliffe Black. Jasmine Court residential complex has now been built on this site.

# People and their Places

Dr Christopher Duffield Briggs (1856-1946), his wife Catherine Rosa and adopted daughter Margaret Lawton (later Taylor) photographed around 1930. The doctor was blinded as a young man in a laboratory accident, but still managed to run a successful medical practice in the area for fifty years using an assistant to act as his 'eyes'. Interested in literature, the arts and a keen supporter of local sport, he also enjoyed playing bridge, making his own 'Braille' cards by pricking the designs out with a pin. Catherine was the widow of James T. Cooper, a Lancashire cotton merchant, whose father Alfred Cooper lived at Wigston Hall in the 1870s.

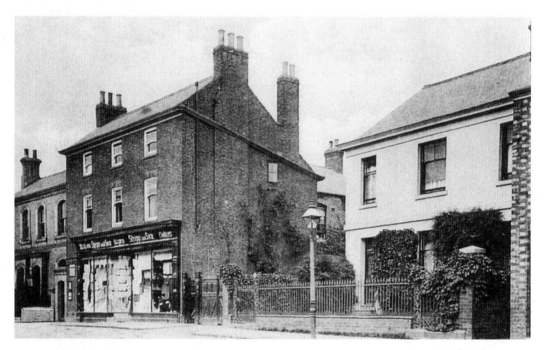

Bell Street, *c.* 1914. Dr Briggs moved to Thacnashee, the white house on the right, when he married in 1921. It was the home of Catherine Cooper and her late husband. She is believed to have chosen the house name which means 'house of the fairies' reflecting her Irish descent. Prior to moving here, Dr Briggs was in partnership with Dr Ekins and lived with him and his wife at The Chestnuts, Spa Lane.

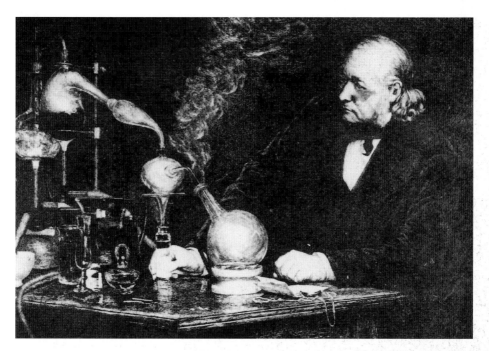

Henry Davis Pochin (1824–1895) was a great-grandson of Henry Davis (Congregational minister 1766–1815). He studied chemistry with the Pharmaceutical Society, moved to Manchester, and invented alum cake, used in papermaking and distilled rosin for soaps. He started his own company H.D. Pochin & Co. Ltd, which is now split and absorbed into Boots and GSK. He was the director of twenty-two other businesses trading in iron, coal, shipbuilding and railways etc., which he turned around and made into limited liability companies. He lived at Bodnant Hall, North Wales, and created its gardens now owned by the National Trust.

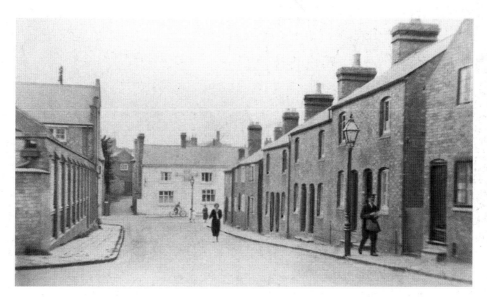

Mowsley End looking towards the Bulls Head, *c.* 1950. This was H.D. Pochin's childhood home; his father William, farmer, butcher, innkeeper and postmaster lived there during the 1830s.

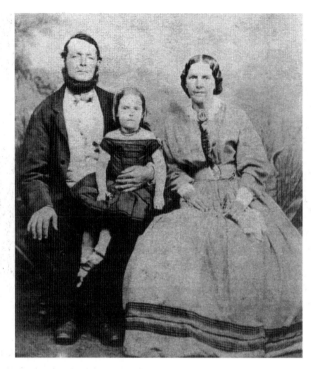

James Hodges (1827-1889) and his wife Betsy, *née* Phipps, photographed in about 1867 in Pietermaritzburg, Natal, South Africa, where they had emigrated in 1860. A carpenter and sawyer, James established a successful business supplying the government with timber, notably the first telegraph poles used there. In 1877 diamonds were discovered at Kimberley and the family trekked north and lived under canvas initially. James' first job was to construct a ladder replacing the ropes then being used. The family returned to Wigston in 1879, probably for safety reasons when the Zulu War broke out.

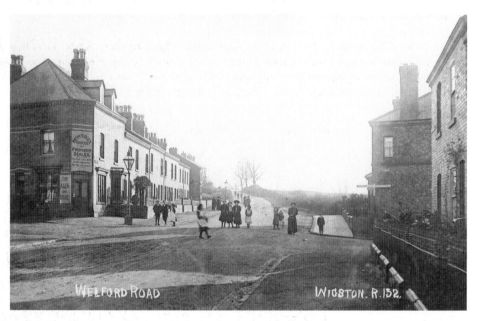

The Crossroads looking towards Kilby Bridge, *c.* 1905. The Hodges returned wealthy and built the grocery shop premises and houses beyond, named Colesberg Cottages, to remind them of South Africa. They ran the shop and Betsy's name is over the door. Later proprietors were the Ludlams and more recently Bruce Freckingham. It has now been replaced by a block of flats and modern housing. The Hodges also assisted financially with the rebuilding of the Primitive Methodist Chapel, Moat Street, in 1886, and Betsy has a named stone in the wall.

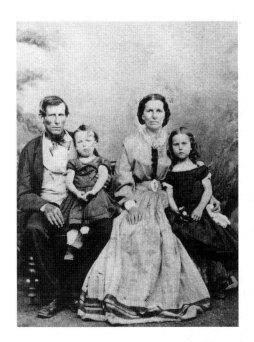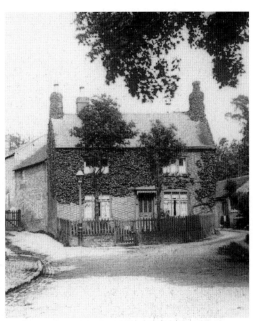

*Above left:* John Goodin (1824–1906) and his wife Martha, *née* Phipps, photographed at the same time as the Hodges. John was also a carpenter and sawyer and they joined the Hodges in South Africa in 1861. The couples were close, the two wives being identical twins. The four remained together in South Africa and returned at the same time.

*Above right:* Mowsley House (*c.* 1910) which was situated across Spa Lane at its junction with Mowsley End. The Goodins bought this and 25 acres of land to the rear when they returned from South Africa. Their son Thomas ran a ginger beer company, utilizing the fresh spring water on site, for many years. The house remained in the family until it was demolished in the 1930s.

A modern photograph of the aptly named Kimberley House, built by John Goodin for his own occupation. The family also built the pair of dwellings known as Natal Cottages in Cherry Street and assisted financially with the rebuilding of the Wesleyan Methodist Chapel, Frederick Street, in 1885, John having a named stone in the wall there.

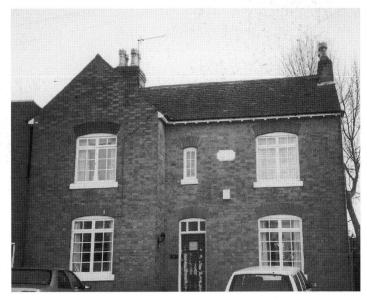

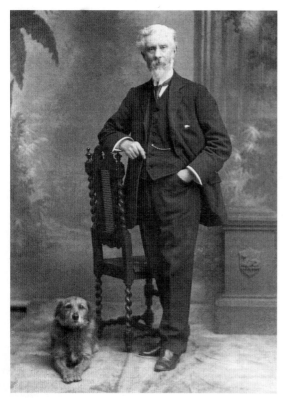

*Left:* Samuel Broughton Matthews (1847–1927) followed his father, also Samuel Matthews, as a stonemason. Many gravestones in the cemetery bear witness to his engraving skills. He was also a plumber, paperhanger, artist and photographer. He was involved in the building of the village hall situated in Frederick Street and was its one and only secretary for sixty years. A lifelong member of the Independent Chapel, Long Street, he was appointed a Trustee in 1890. There is a commemorative window in the chapel describing him as 'teacher, superintendent, deacon and treasurer [for] sixty years'.

*Below:* S.B. Matthews standing outside his house and business premises in Leicester Road, *c.* 1917. On the left is his apprentice Douglas Simpson. All these properties from Aylestone Lane corner to the Bell Inn have now been replaced by modern shops.

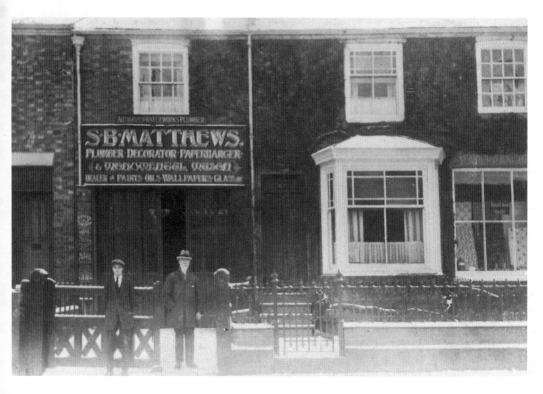

*Right:* John Thomas Proctor (1846-1932) was
a solicitor's clerk and worked for A.H. Burgess,
a nephew of Thomas Burgess (see page 38). A
devout Wesleyan Methodist, he served as a lay
preacher for sixty years. He financially supported
the enlargement of the chapel in Frederick Street
and is also named on a stone in the wall. He served
variously as clerk, secretary and attendance officer
to the managers of Wigston School Board, and was
founder of the adult school. A talented artist, several
of his watercolour scenes of Wigston exist.

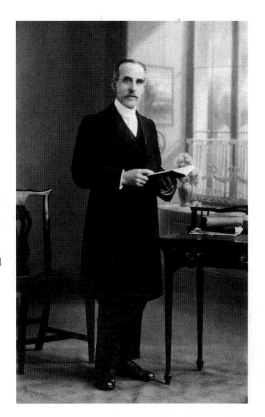

*Below:* Oadby Lane showing St Wolstan's Church,
*c.* 1904. The house between the church and the
row of cottages on the left was J.T. Proctor's home
in Burgess Street. He named it Sleaford Villa after
the place of his birth. It and the cottages were
demolished to make way for the widening of Bull
Head Street and associated traffic island.

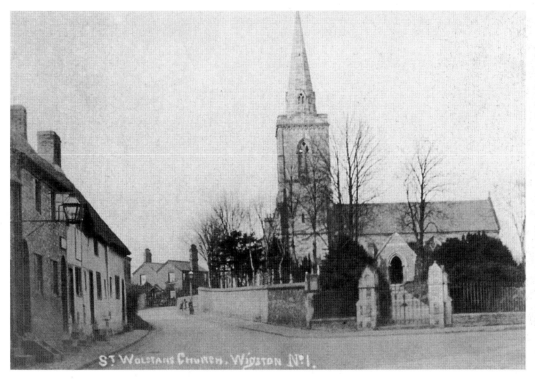

ST WOLSTANS CHURCH, WIGSTON N°1.

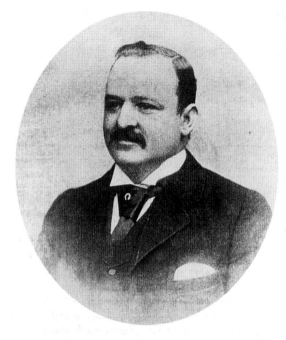

Orson Wright (1853-1913), carpenter cum speculative builder, created whole housing estates in Leicester and beyond but is mainly remembered as the creator of South Wigston. He founded other companies too – boot and shoe, hat and cap, brick and tile works – and was chairman of Wigston Gas Co. Wright gave land for the building of St Thomas's Church, but didn't win the contract to build it. He served as a JP and councillor and was a big supporter of Leicester Fosse (later City) Football and County Cricket Clubs. On the day of his funeral all local businesses closed and representatives of 300 organisations filled St Thomas's, where his family have since given a memorial window.

In Memoriam.

## Orson Wright, J.P.

Born
July 23rd, 1853.
Died
April 10th, 1913.

Interment at
Wigston Magna Cemetery,
April 14th, 1913.

*Above left:* A modern photograph of Venetia House in Canal Street which Orson Wright built as his first home in South Wigston before moving to Ashbourne House in Blaby Road. It was later incorporated into the Grand Hotel.

*Above right:* The front cover of the Order of Service booklet produced for the funeral of Orson Wright.

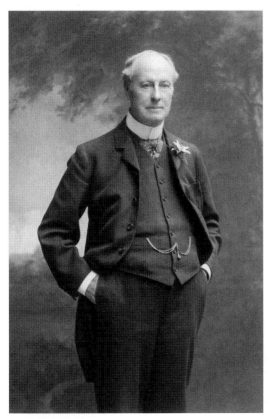

*Left:* Hiram Abiff Owston (1830-1905) a Leicester solicitor who trained under Richard Toller. He became president of the Law Society, director of the Leicester Banking Co. and the Commercial Union Insurance and solicitor to the Grand Union Canal Co. He was also the author of various law books. He helped establish the new church of St Thomas and was a sidesman at All Saints Church, donating the chancel screen there. As well as being a JP and a councillor, Owston was chairman of Wigston UDC. Mother of Pearl mosaics each side of the alter in All Saints were donated by the family in his memory. His name continues today in the legal practice of Harvey Ingram Owston.

*Below:* Bushloe House, Station Road, *c.* 1910. H.A. Owston bought the house and enlarged it in 1866 upon his marriage. The decoration and furniture are attributed to Christopher Dresser. Fond of horticulture, the gardens were a noted feature, and his interest in drama resulted in the creation of an open-air theatre in the grounds. It now houses Oadby & Wigston Borough Council Offices.

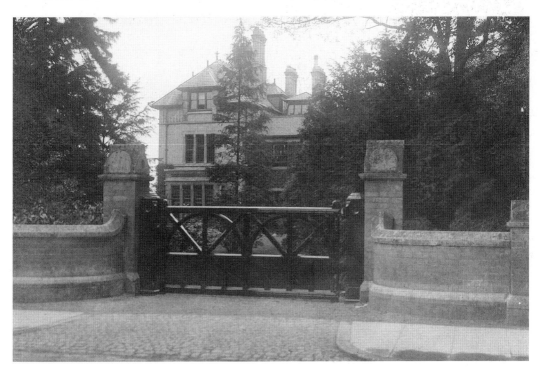

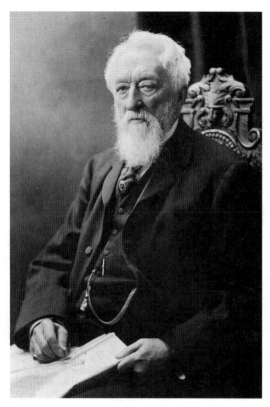

*Left:* Thomas Ingram (1810-1909) was a Leicester solicitor. He was registrar of the County Court for forty-two years, clerk to Billesdon Poor Law Union for fifty-five years, solicitor to Wyggeston Hospital Trust for thirty years and served as High Bailiff in 1888. He moved to Wigston in about 1862 and his generous deeds included building a wall, a porch and buying a bell for St Wolstan's Church, plus a window in memory of his parents, a sixth bell, the organ and wall for All Saints. He also gave £1,000 towards the building of St Thomas's Church and later funded the tower, eight bells and organ. His name also continues today in the legal practice of Harvey Ingram Owston.

*Below:* A modern view of Hawthorn Field, Thomas Ingram's home which he had built on land off Station Road. Note that it is constructed of granite, as are the two church walls he had built, obviously a favourite material. The name was changed to Abington House when inherited by his nephew, the Revd C. Mortlock. The house now serves as an annexe to Abington School which, together with Guthlaxton and Bushloe Schools, were all built in the grounds.

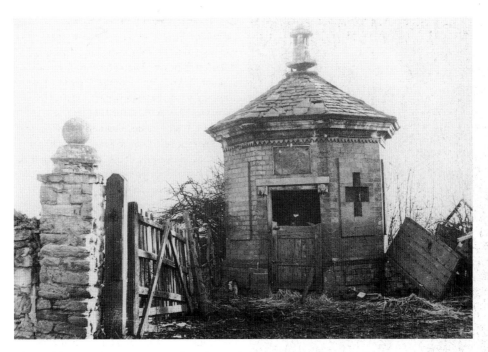

This conduit stood in Leicester Market Place. It housed a water tank to retain water piped from a spring in fields near the present Conduit Street. On special occasions the town authorities would substitute ale for the water. It was removed in 1841 and was later brought to Wigston as a feature for Thomas Ingram's garden. It is pictured here in 1962 shortly before demolition.

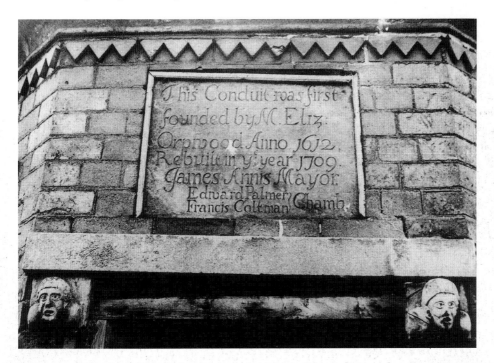

A close-up of the plaque giving information on the origins of the conduit.

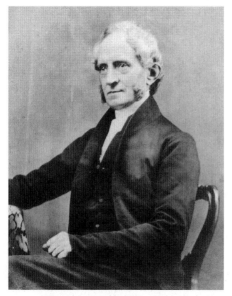

Thomas Burgess (1799-1874) lived most of his life at The Grange in Leicester Road. His family, who were Quakers, had farmed in Wigston since at least 1700. Thomas continued this tradition but was also in business with his brother Alfred as Burgess Bros, wool staplers, at 1 Belvoir Street, Leicester. His sister Emma had married Edward Shipley Ellis, eldest son of John Ellis, leading industrialist and founder of the Midland Railway. Thomas played a leading role in local life, attending and chairing vestry meetings, founding the gas works in 1857 and with his wife starting an infant school in Bell Street. He also acted as banker for the majority of local clubs and societies.

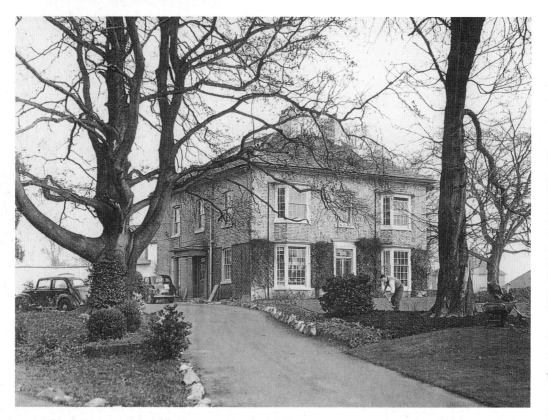

The Grange, Wigston, in the 1950s. It was built around 1825 by John Burgess, father of Thomas. After the death of Thomas it was sold and had several owners before serving during the First World War as a home for Belgian refugees. It was restored in the 1920s and more recently has been occupied as business headquarters. The farmland was developed and now forms The Grange estate.

three

# Gone but not Forgotten

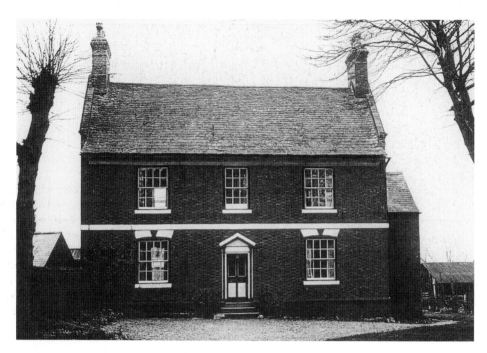

Rectory farmhouse in 1958, before its demolition ten years later when a staircase was salvaged and placed in Donington Manor House, near Hugglescote. The farmhouse stood next to All Saints Church and was probably built around 1766 when the estate was awarded at enclosure to the third Duke of St Albans, whose grandfather, the first duke, was a son of Charles I and Nell Gwynne. In 1919 it was bought by Wigston Co-operative Society who farmed the land to extend their milk business.

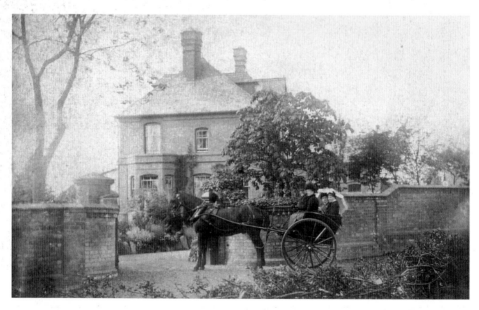

Homefield in Aylestone Lane, c. 1900. In the pony and trap is believed to be the owner, Ambrose Lee, founder of Two Steeples hosiery company. Later owners were Josiah Hincks, solicitor, and A.H. Broughton, hosiery manufacturer. Curtis Weston House now occupies the site.

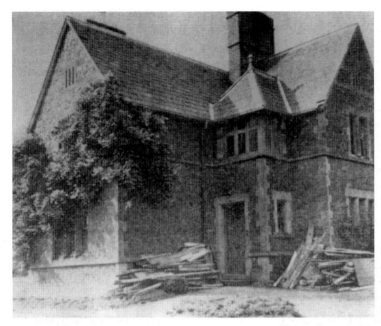

The Cemetery Lodge House was built around 1880 at the time the cemetery was opened. It was replaced by a modern house in the 1970s due to dry rot. The foundations now form part of the Garden of Remembrance.

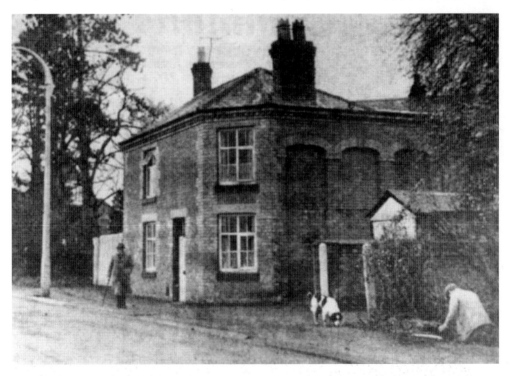

This house stood on Leicester Road, Wigston Fields, close to the entrance to Fir Tree Close. It is of unusual design and was perhaps built as a gatehouse, the windows to the right offering a good view of travellers approaching from Leicester. It was once home to the Bliss family but was demolished in the 1970s due to road widening. One side of the property with the arch design survives as a boundary wall to the neighbouring pair of semi-detached houses.

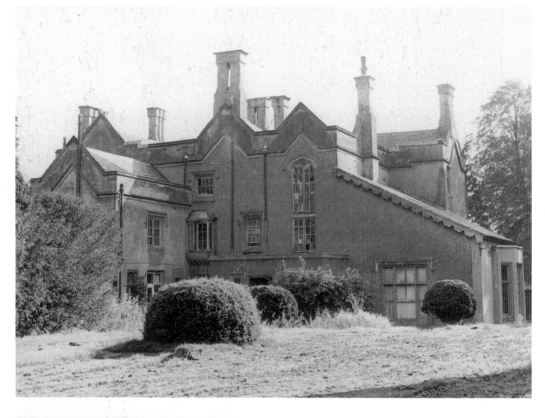

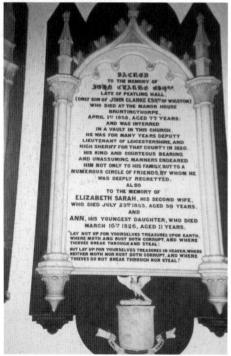

*Above:* Wigston Hall from the rear, just prior to demolition, *c.* 1963. Elizabeth Court flats are now on the site. The Hall had long been the 'seat' of the Clarke family, though when John Clarke (1781–1858) married he lived at Peatling Parva Hall, leaving his mother and sister Ann at Wigston. When Ann married Capt. Baddeley in 1831 the Hall was enlarged for their use. After their death it was let but remained in family ownership until 1898.

*Left:* Memorial in St Andrew's Church, Peatling Parva, to John Clarke (mentioned above) and his second wife Elizabeth. There is a matching one next to it to his first wife Catherine Martha.

*Opposite below:* These almshouses were erected in Long Street, on the corner of Blunts Lane, in 1781, following a bequest under the will of Elizabeth Clarke, aunt of the John Clarke above. She left £3,000, a huge sum in those days, to build and endow them. They were demolished in 1965 and replaced with the present bungalows. The original plaque is retained on the new buildings to remind us of her generosity.

One of the later owners of Wigston Hall in the 1920s/30s was Thomas Birkett, seen here with his wife Edith. They had family connections to both the Toones and the Blacks of the boot and shoe company in Saffron Road.

The Poplars, *c.* 1935. From the 1930s until 1959 The Poplars was the home of Frank Freer who gave it to the Wigston UDC for community use. He also sold the paddock at the rear to the council, for a nominal cost, for use as a recreation ground. The house was demolished in the 1970s and The Poplars Community Centre now occupies the site.

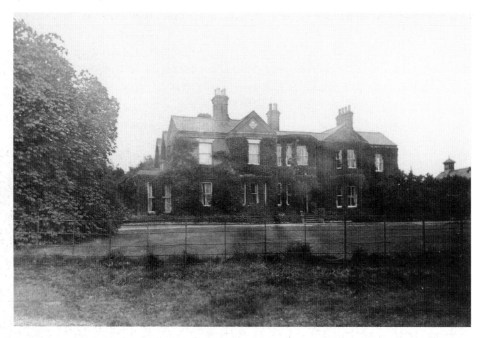

The Grange, Glen Parva, was the home of Sir John F.L. Rolleston from before 1908 until his death in 1919, his widow continuing there well into the 1930s. He was a specialist in arboriculture and there was a fine collection of trees in the grounds. Sir John, a surveyor, negotiated much of the land purchase for the Great Central Railway and was land agent to the Eyres Monsell family. The house was requisitioned during the Second World War and demolished about 1946.

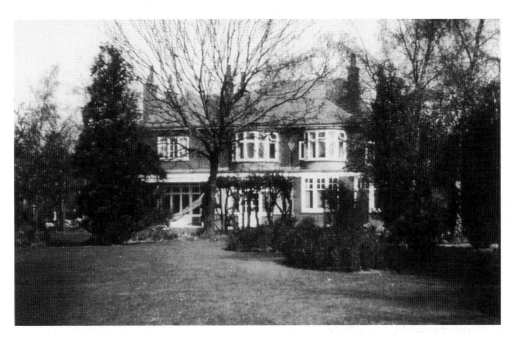

A rear view of Beech House, Aylestone Lane. It was built in 1908 and was the home of John A. Broughton, of J.D. Broughton & Sons Ltd, hosiery manufacturers in Bell Street. In 1946 the house was badly damaged when a Lancaster bomber broke up in a thunder storm and large pieces crashed onto the house and garden. It was demolished in the 1960s and Beech Court built on the site.

This row of properties stood on the corner of Bull Head Street and Newton Lane. The corner one was Levi Sampson's pork butcher's shop, predecessor to Frank Foster. They were demolished around 1972.

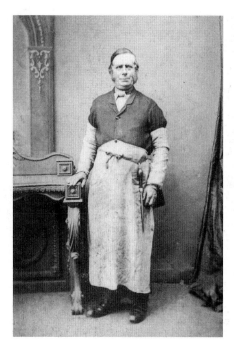

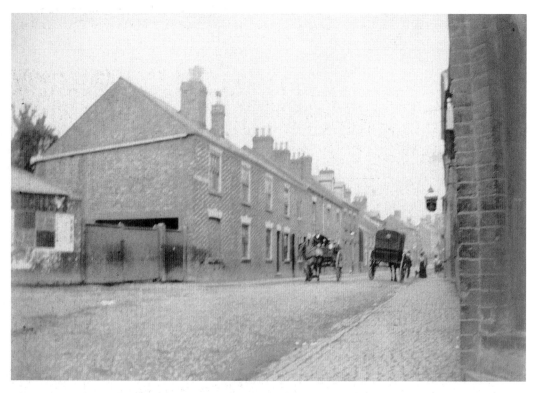

*Above:* A black-edged memorial card to William Forryan typical of the period.

*Left:* This photograph shows William Forryan (1810-1892), farmer and butcher, of Bell Street. He served on the parish council from 1847 and is great-great-grandfather to co-author Duncan Lucas who has recently retired as a county councillor for the area. This brings to an end 163 years of continuous service to the community.

This group of buildings at the bottom of Bell Street photographed around 1910 and the farmyard and orchard round the corner in Leicester Road, were owned by William Forryan and his descendants for many years. All were demolished around 1971 and replaced by a parade of shops.

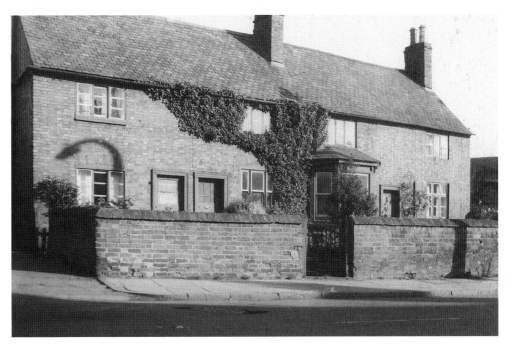

This row of three cottages, thought to date from the mid-1700s, stood in Long Street next to the Post Office sorting rooms. They were demolished around 1967 and a doctors' surgery now occupies the site.

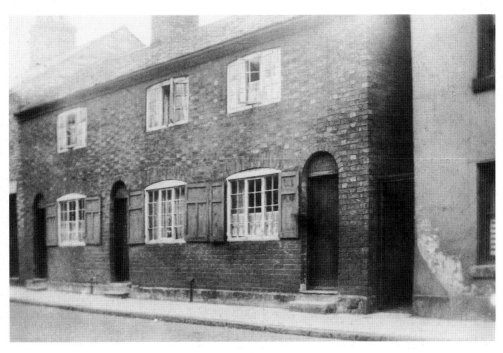

Another row of three cottages, these stood on the south side of Bell Street. In 1938 a Mr and Mrs Walden lived in No. 25, the centre one. The Co-operative Society department store now covers this site.

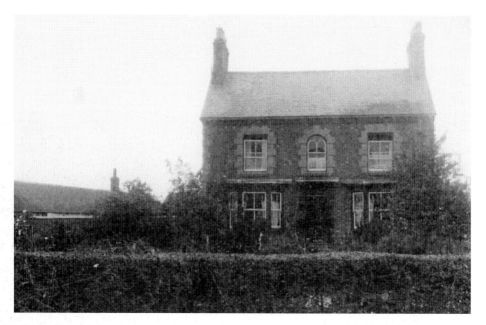

This house, known as Compton Cottage, at 299 Leicester Road, was the home of William Horlock. It was situated on a large plot which he cultivated as a market garden. The site is now occupied by the Wigston Stage Hotel.

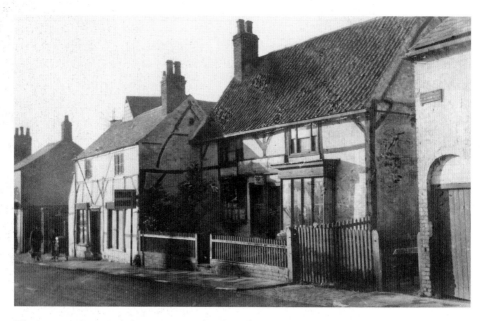

These two ancient cruck-beam cottages stood on the west side of Bull Head Street. The far one was a Quaker Cottage at least 400 years old and originally a farmhouse. It incorporated a carved beam with the Quaker motto 'above al thyng sware not but ye and na' which is now preserved at the council offices. It was demolished in the 1970s. The nearer one was the property of Samuel Laundon, a saddler and harness-maker. A replacement house was later built at the back, but this too has now gone and the site is part of the Bell Fountain car park.

four

War and
Peace

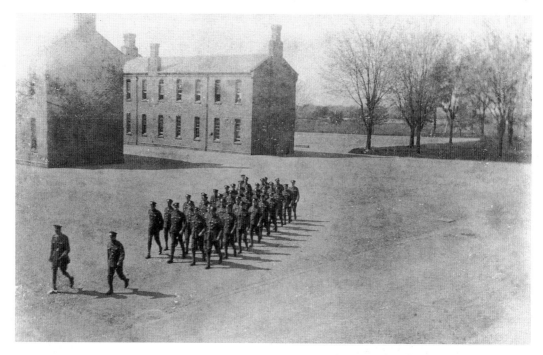

An orderly block of soldiers being marched across the square at the barracks in Saffron Road, *c.* 1906. The barracks was built between 1877/80 on Grange property and could accommodate 500 men. It became the base for the Leicestershire Regiment and always played a key part in South Wigston life particularly during the two world wars. It was run down in the 1960s. Many of the regimental flags hang in St Thomas's Church.

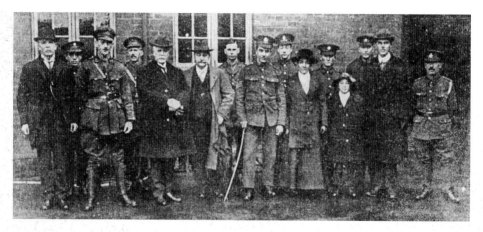

During the First World War, Wigston lad William Ewart Boulter was awarded the VC. He was invited back to his old school in Long Street (now Leicestershire Record Office) on 30 October 1916 for a reception. From left to right are: J.D. Broughton, B. Broughton, -?-, -?-, J.W. Black CC (Chairman of the School Managers), Fred Boulter (father), Lt C.M.B. Boulter (headmaster's son), Sgt Boulter VC, -?-, Mary Ann Boulter (mother), -?-, -?-, -?-, Capt. Brockington (County Director of Education), -?-. William Boulter's VC and four other medals are now with the Northamptonshire Regimental Collection, Abington Museum, Northampton.

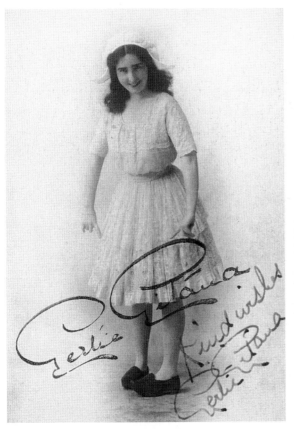

*Left:* Gertie Gitana (1887–1957) was a music hall artist who married Don Ross, son of Alfred Ross, headmaster of the National School. During the First World War thousands of postcards such as this one were sold to raise money for the troops. She was known as the 'Tommy's Song Bird' and is regarded as the 'Vera Lynn' of that time.

*Below:* This group of South Wigston youngsters photographed in 1915/16 are depicting 'A War Wedding' and were part of a fancy dress procession to raise money for parcels for the troops.

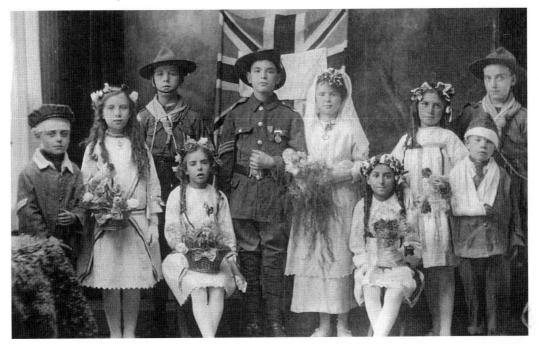

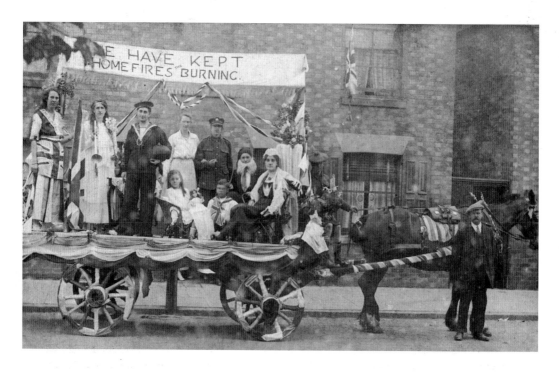

# United Peace Service

of the Anglican and
Free Churches —

in the

## Parish Church, Wigston Magna

Sunday July 6th, 1919, at 3 p.m.

Conducted by

### Rev. T. W. Wright, M.A.

Assisted by

### Rev. J. Gari Phillips, B.A.

and

### Mr. A. H. Broughton.

Collection for the Wigston Peace Memorial Fund.

DEEMING BROS., PRINTERS

*Above:* 'We have kept the home fires burning', a beautifully decorated float in a parade which formed part of the Peace Celebrations in 1919. From left to right: Miss Lucas (Britannia), Miss King (Peace), Miss Herbert (Navy), Miss Herbert and Miss Possnett (Army), Miss Randle (Old Man), Miss Copson (Old Lady), and children Kitty Measures and N. Smith. The driver was Tom Mason.

*Left:* Front cover of an Order of Service sheet for a United Peace Service held to celebrate the end of the First World War and to raise money for the creation of a Peace Memorial Park. The Revd Wright was the Anglican minister, the Revd Phillips the Congregational minister, while A.H. Broughton represented the Methodist churches. The hymns chosen were 'O God our help in ages past', 'Father let thy kingdom come' and 'God is working his purpose out'.

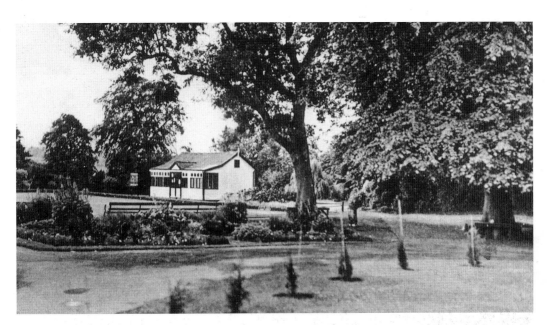

The land for the Peace Memorial Park was bought in April 1921 for £741 5s 0d from Albert E. Hill. This picture was taken before the trees were felled, *c.* 1936. To celebrate the millennium the park has been given a makeover which includes a distinctive new pavilion to replace the one shown. Cllr Boulter then organised the addition of a memorial plaque to the fallen of both conflicts, adding some names omitted from other memorials, and the Rotary Club have gifted a tall flag pole.

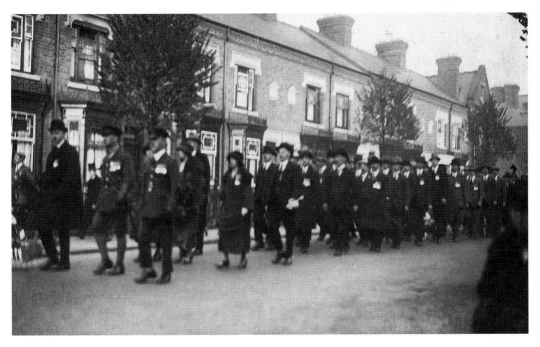

Ex-service men and women from Wigston, South and Glen Parva parade on Armistice Day, 11 November 1921, in memory of the fallen.

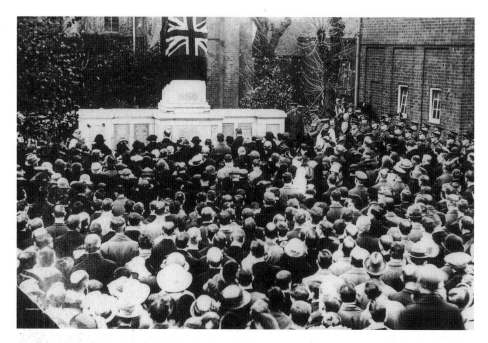

Crowds gather at the South Wigston war memorial for another Armistice Day service, *c.* 1930. Troops from the barracks used to join public figures for the wreath-laying ceremony. The memorial was cleaned and restored in 2003.

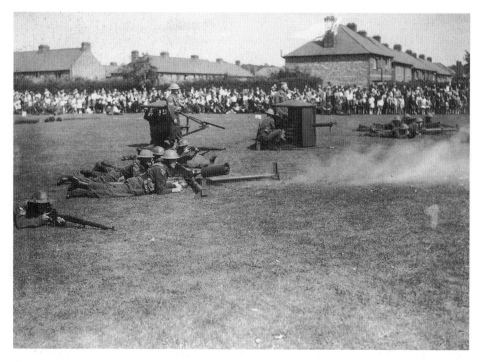

The Home Guard undergoing training exercises at the end of Lansdowne Grove watched by a large crowd of locals.

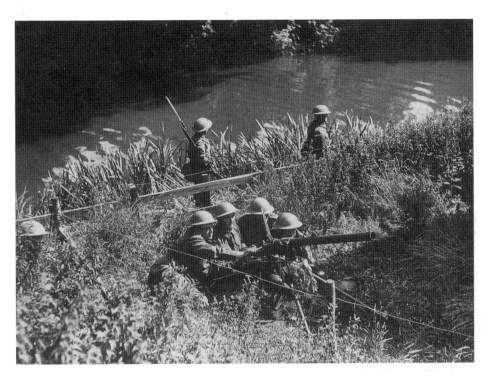

Similar exercises probably on the same occasion but this time nearer the canal.

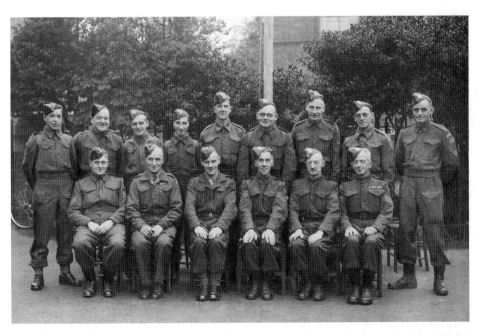

A Home Guard group pose for a photograph on the playground of the National School. Behind them is 22 Long Street, the home and butchery premises of Francis H. Freckingham. From left to right, back row: -?-, -?-, -?-, -?-, Iliffe Boulter, Cliff Savage, Horace Skerritt, -?-, Bill Foulston. Front Row: -?-, ? Crabtree, Lt Tuckley, Dick Hardy, P. Holgate, George Simpson.

This picture was taken around 1948 in the yard of Goldhill Lodge Farm, which was at the top of Aylestone Lane, where Wheatcroft the builder's offices were later situated. The hut behind the calf was used by the Home Guard between 1940/45 as a dormitory and billiard room.

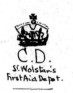

C.D.
St Wolstan's
First Aid Depot.

To Wish
Miss Newman

The Best of Luck
Good Conditions and
Happy Days in her
New Sphere of Service.

From her old party
at St Wolstan's.

W·A·A·F·

C.D.
St Wolstan's
First Aid party
H Hurst Depot officer
C T Shaw

J. H. Smith.
A S Knight
S. E. Stickford
L Gray
M. Markell
E Gray.
P. Meiklejohn
E. Hilton

This home-made card from the early 1940s was to wish Miss Newman, a member of the Civil Defence, St Wolstan's First Aid party, good luck when she joined the WAAF. Some of the signatories will be familiar; Thomas Birkett is the gentleman photographed on page 43.

This Second World War Billeting Officer's Identity Card states on the reverse that any occupier of premises must furnish to the officer true information with respect to the accommodation contained, and persons living therein, and provide accommodation in the premises to all persons he may assign there.

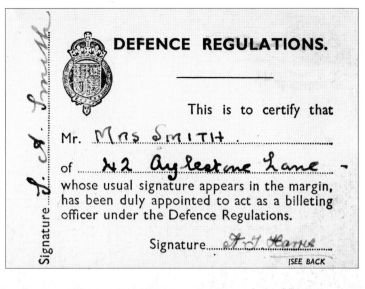

DEFENCE REGULATIONS.

This is to certify that

Mr. *Mrs Smith*

of *42 Aylestone Lane*

whose usual signature appears in the margin, has been duly appointed to act as a billeting officer under the Defence Regulations.

Signature *J. J. Harris*

[SEE BACK]

Signature *J. A. Smith*

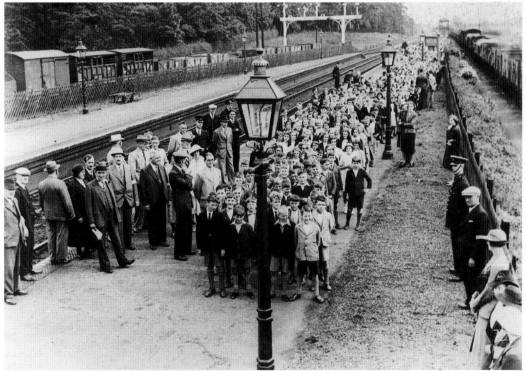

When the authorities were advised they were to receive large numbers of evacuee children, a rehearsal using pupils from local schools was organised. This picture from 1939/40 shows the station platform full of these eager volunteers. The nearest ones are, from left to right, first row: Peter Clowes, Henry Bircham, Frank Simpson, George Marquis. Second Row: Peter Smith, Harry Walters, Derek Matthews, Arthur Tandy, Bertram Gill. Third Row: Gerald Watkins, Roy Mason, Norman Jennings, Maurice Hassell, James Forryan. Among the adults on the left are: William Gunning, Curtis Weston and Harry Holmes (councillors and staff), and Robert Kind, Hylton Herrick, Harry Marshall and 'Kipper' Broughton (teachers) plus Nurse Mould.

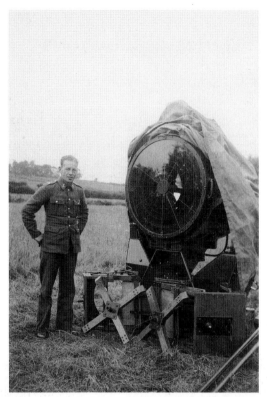

*Left:* The co-author's father Alfred Broughton, plus searchlight, somewhere in Lincolnshire in 1939. Such searchlights were also positioned locally on the sports ground at Wigston Road, Oadby near the Washbrook.

*Below:* When VE Day arrived on 8 May 1945 huge celebrations took place in Wigston as elsewhere. People congregated at the Bank and dancing took place. The ATC had used what was later to become John Ray's fish and chip shop as their wartime HQ, and they quickly rigged up music to play in the street for the occasion. John Ray opened his shop when he was demobbed after the war. It closed in the 1980s and is pictured here awaiting demolition.

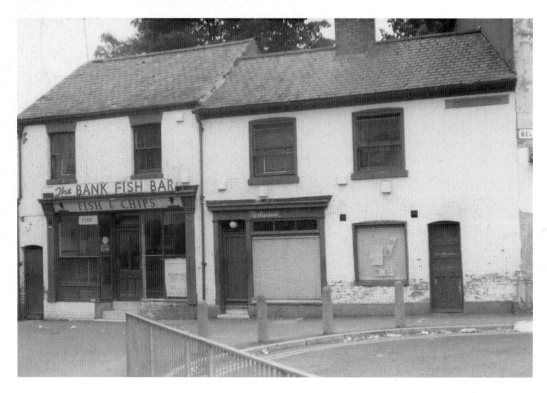

five

# Places of
# Worship

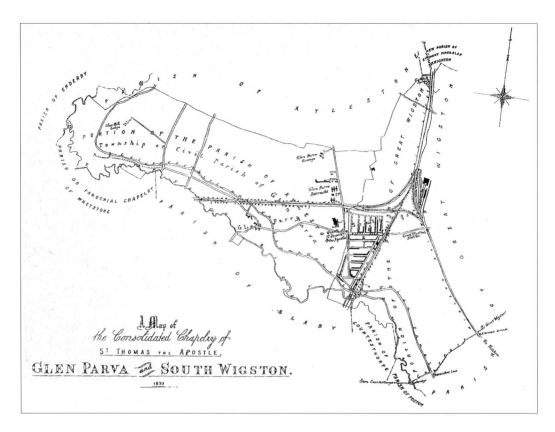

A Map of
the Consolidated Chapelry of
ST. THOMAS THE APOSTLE,
GLEN PARVA and SOUTH WIGSTON.
1883

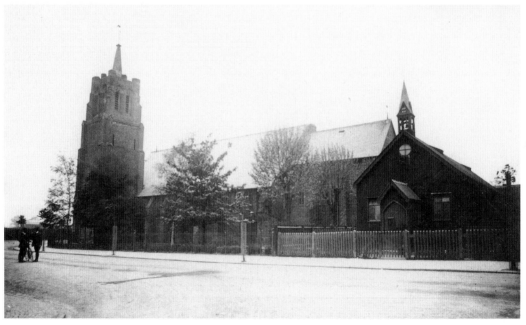

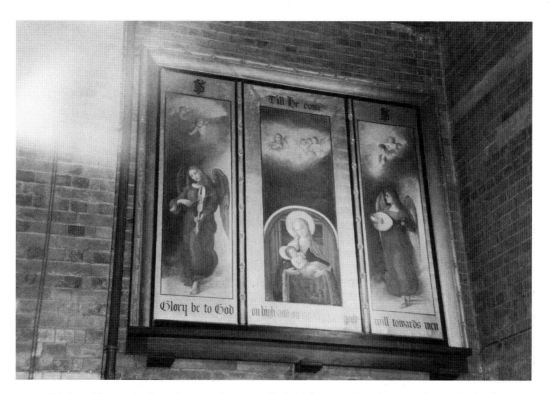

This beautiful mural of angels graces the rear wall of St Thomas's Church. It was the work of Lady Rolleston of Glen Parva Grange, who was a talented artist and copyist.

*Opposite above:* A new parish of Glen Parva and South Wigston was created in 1893. This map shows the boundaries of it and the areas of neighbouring parishes included in it.

*Opposite below:* St Thomas's Church, *c.* 1910. The church had been built in 1893 with the tower added in 1900, but was minus a clock at the time of this photograph. The 'tin tabernacle' mission church on the right had served the congregation from 1886 until St Thomas's was built, after which it was used as school rooms. These little churches were made in Lincolnshire by Boulton & Paul and sold in kit form all over the world.

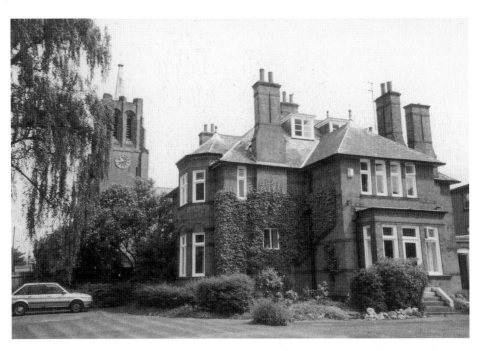

A modern picture of the vicarage, built in 1895, with St Thomas's Church visible to the left.

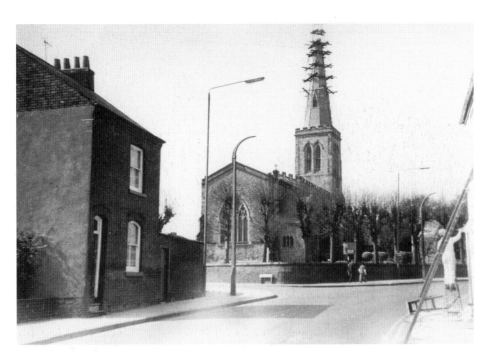

All Saints Church, taken in 1973, showing the tower with some very precarious-looking scaffolding in place. The earliest part of the structure is believed to date from the fourteenth century. The east window facing the camera was donated by Captain Baddeley of Wigston Hall in about 1854 in memory of his wife and son.

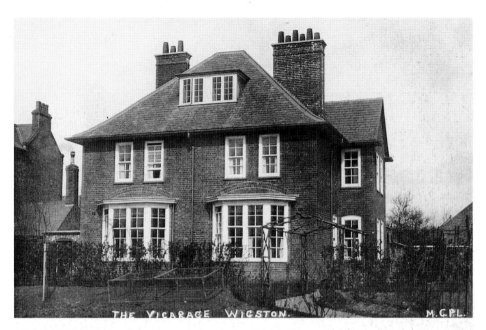

All Saints Vicarage seen from the rear, when it would have been quite new, having only been built in around 1912, a similar date to the photograph.

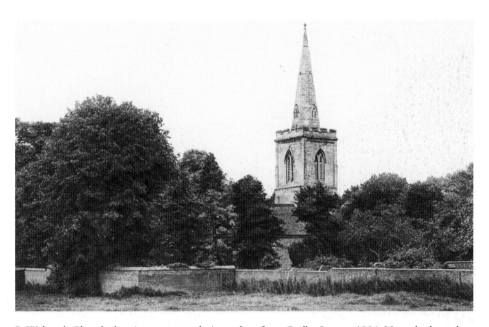

St Wolstan's Church showing an unusual view taken from Oadby Lane, *c.* 1904. Note the boundary wall then of brick and the field in the foreground which is now St Wolstan's Close. The little church, the tower of which dates back to the thirteenth or fourteenth century, was originally dedicated to St Wistan but for unknown reasons was changed to St Wolstan's many years ago. When this was discovered in the 1950s it was decided to revert to the original dedication amid much local controversy.

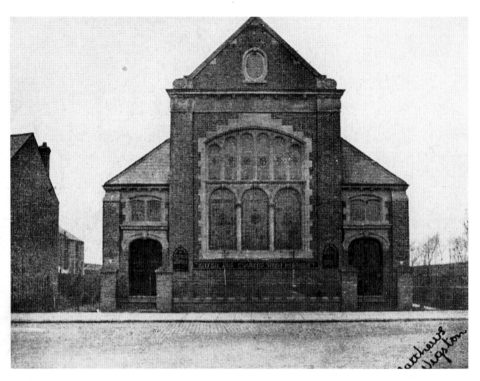

This Primitive Methodist Church was built in Countesthorpe Road in 1900 and the photograph dates from soon afterwards. The congregation merged with the Wesleyan Methodists in Blaby Road in 1967 and this building was demolished in the early 1980s. Best Close is now on the site.

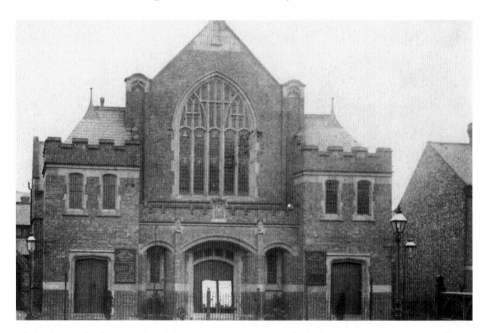

Wesleydan Methodist Church, Blaby Road, *c.* 1905. Originally built in 1886 it was substantially rebuilt in 1902 in front of the existing church which was then used as a school room.

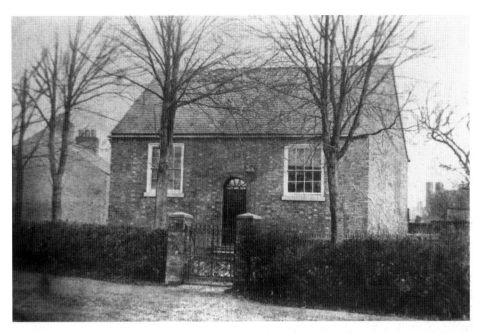

This picture of uncertain date shows the first Primitive Methodist Church in Moat Street, built in 1846. It was their first purpose-built place of worship although it is known there had been a congregation in the village since 1818.

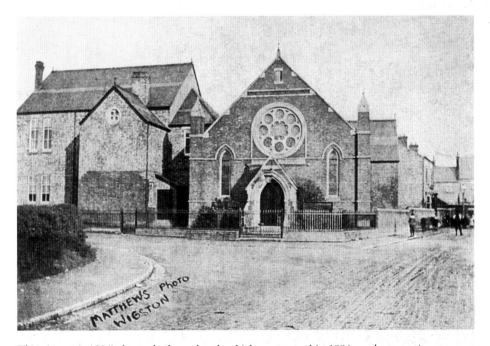

This picture (*c.* 1904) shows the later church which was erected in 1886 on the same site. The church has been much enlarged over the years, and in the 1980s underwent a complete transformation of the interior when the Wesleyan Methodist congregation merged with them. It was thereafter known as the Wigston Magna Methodist Church, Cross Street.

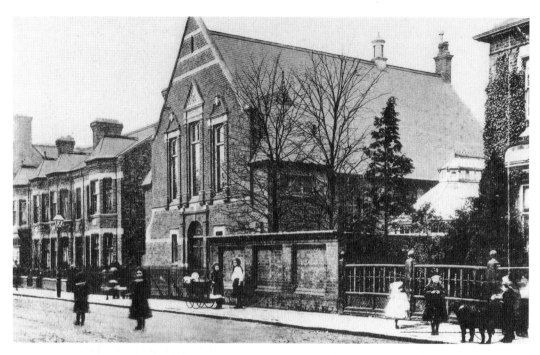

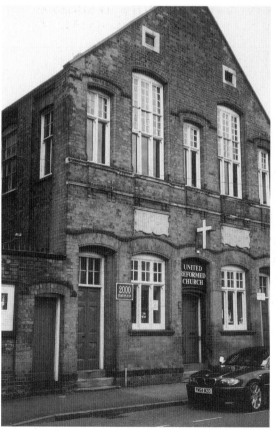

*Above:* Congregational Church, Blaby Road, *c.* 1912. The Congregationalists had begun to meet in South Wigston in 1885 as a mission of the Wigston Magna church. They bought some land and erected a mission church the following year. The present building was opened in 1897 on the same site.

*Left:* Modern photograph of the United Reformed Church in Canal Street. This church was originally built as a Christian Meeting House/Church of Christ. The congregation met in Benjamin Toone's warehouse, a part of his factory (the same Mr Toone who was a partner in the Toone & Black shoe factory). He later built the church on land adjoining. In 1892 it was damaged by fire from an adjacent factory and restored and enlarged. In 1903 the congregation bought it from him. In 1981 the members became part of the URC.

A modern photograph of the Catholic church of St Mary's on Countesthorpe Road. Local Catholics used to worship at the barracks where services were regularly held for the high number of Irish Catholic personnel in the army. This led to the establishment of a separate church in 1905.

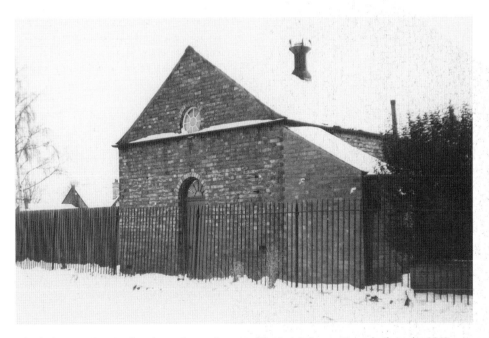

This little Strict Baptist chapel stood near the top of Frederick Street. It was built in the 1860s by James Levesley at the rear of his drapery shop premises in Bell Street. Mr Levesley's daughter married her father's apprentice, Samuel Shipp, who in time took over the business. The chapel was demolished around 1964.

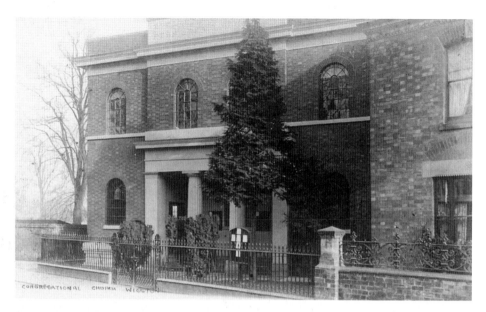

Congregational Church, Long Street, *c.* 1903. A group of independents were formed as early as 1666 and built their first church in 1731, when they were described as of the Presbyterian persuasion. The church was rebuilt in 1841. It was opened by George Davenport of Oxford, a banker, whose grandfather had been much involved in building the original. The members eventually became Congregationalists and in 1972 joined the United Reformed Church. The tomb to the left of the forecourt is that of William Pochin, the father of H.D. Pochin (see page 29).

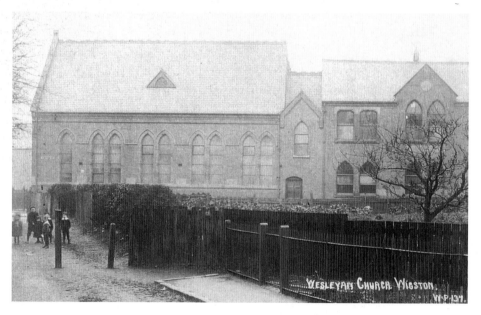

Wesleyan Methodist Church, Frederick Street, *c.* 1913. A group was formed around 1820 and built their first church on this site in 1839. In 1885 the present building was constructed at the front of the original, some of which survives. In the 1980s the congregation decided to merge with the Primitive Methodists in Moat Street and this building was sold to the Central Pentecostal Church.

six

Public
Houses

Wigston, Leicester.

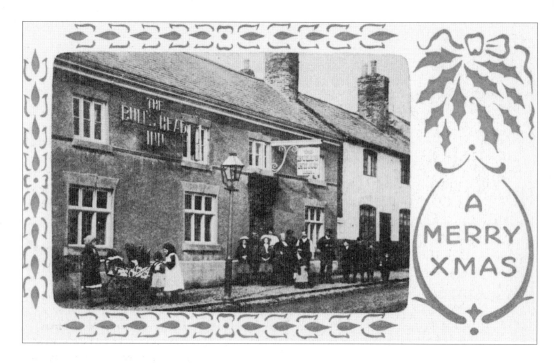

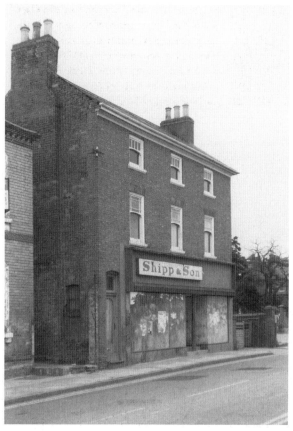

*Above:* Bull's Head Inn, Bull Head Street, shown on a Christmas Card, *c.* 1910. Records show it to have been in existence since at least 1617. The name probably comes from the Hastings family who had associations with nearby Wistow and whose emblem was a bull's head. It was the main inn in the village and served as a coaching inn as well as hosting manor courts (last in 1838), quarter sessions and inquests. King Vann held the licence in 1825 and Thomas Cook in 1854. Mr Hallam was the last landlord before demolition in 1971.

*Left:* Old Blue Bell, Bell Street, also a coaching inn from the late 1700s to 1848. In 1825 Thomas Coltman held the licence. The property was then purchased by James Levesley and thereafter used as a drapery shop which was continued under the name Shipp. The property was demolished in the early 1970s.

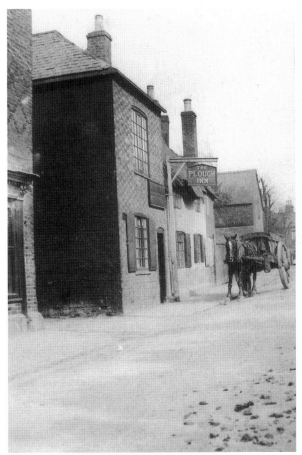

*Left:* The Plough, Bushloe End, seen here with Eli Bailey's horse patiently waiting for its master to finish his drink, *c.* 1900. The name probably relates to the close proximity of the church where the village plough was often kept in ancient times. The licence was held by Henry Burbidge in 1825 and by 1854 it was with the Potter family. It was later rebuilt in a mock-Tudor style.

*Below:* Two inns are seen here in this view of Kilby Bridge, *c.* 1906. The third property on the right is the Navigation Inn built at the time of the canal construction in 1796. James Wagstaff held the licence in 1825 and by 1854 it was John Walden. Considerably altered over the years, it happily survives today. The building on the extreme left was known briefly as the Lime Kilns and then the Black Swan, the former name reflecting that in the early nineteenth century there was a lime-burning business nearby. In 1825 the licence was held by Sarah Gilham. It ceased to be a public house in 1858 following the death of the landlord, David Evans.

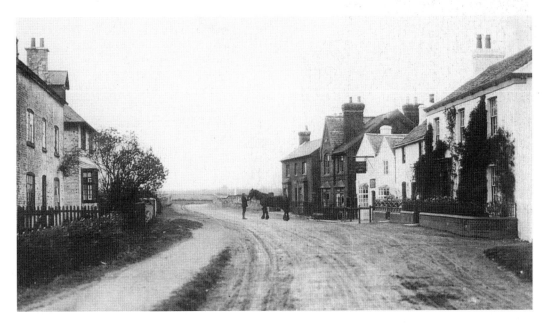

The Horse & Trumpet, Bull Head Street, in the 1920s. It was a substantial house with a large forecourt thought to have once been part of the village green. The licence was held by Joseph Clarke in 1825 and the Mattock family by 1854.

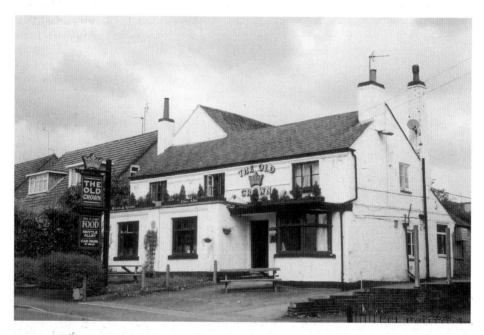

Modern photograph of The Old Crown, Moat Street. Receipts for stabling and victuals in church records prove it dates from at least 1680. Noted for the antics of highwayman, George Davenport (1758-1797) who was said to have danced 'Astley's Hornpipe' on the roof several times in bravado after having escaped capture. In 1825 the licence was held by William Simpson and the Hurst family by 1854.

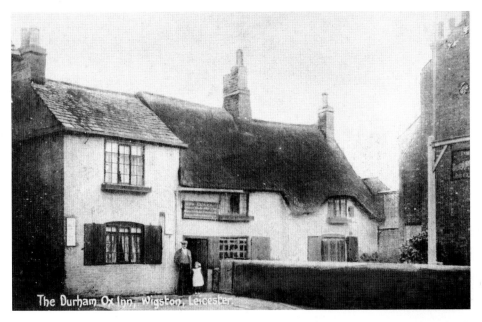

The Durham Ox, Long Street, photographed in about 1915 with licensee Job Clark outside. It stood on the corner of Blunts Lane on a site now occupied by the Cleaning Cupboard. Previously it was known as the Woolpack until 1817 and the Ram's Head before that. The licensee in 1825 was Edmund Fox and by 1854 it was John Johnson. It was closed in 1926 and later demolished. These first eight public houses are the oldest known and were the only ones listed in licensing records for Wigston in 1825, the first year in which the house names as well as licence holders were recorded.

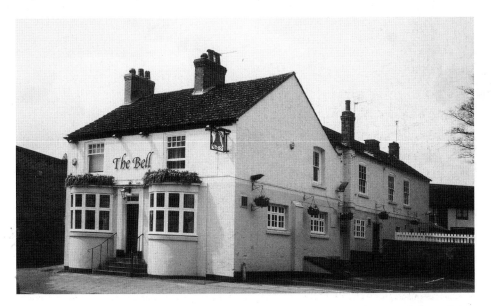

The Bell Inn, Leicester Road, a modern photograph of an inn which was first recorded in 1856 as a beer house and garden run by James Tabberer. The licence is thought to have been moved from the Old Blue Bell in Bell Street. There was once a blacksmith's shop at the rear. It looks very smart due to a recent refurbishment, and having escaped a planning application to demolish it in 1965.

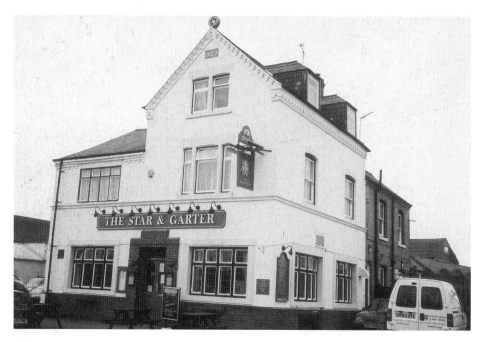

The Star & Garter, Leicester Road, on another modern photograph. The building helpfully displays a date stone showing it was constructed in 1879. In 1881 Frederick Loyley was the licensee. This pub has recently featured in an English Heritage book *Licensed to Sell* because it had retained an original self-contained room with hatch for outdoor sales. It is also looking very smart after a recent refurbishment.

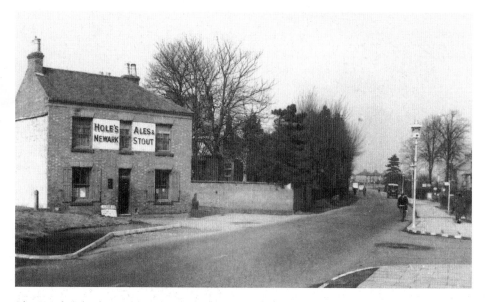

The Royal Oak, Leicester Road, pictured in the 1930s. It was opened as a beer house in 1865 when land at Wigston Fields was first divided up and used for building and garden plots. At that time the licensee was Leonard Sibson, a Knighton man. When this photograph was taken the landlord was Frederick Thorpe but he was soon to leave and the property be rebuilt.

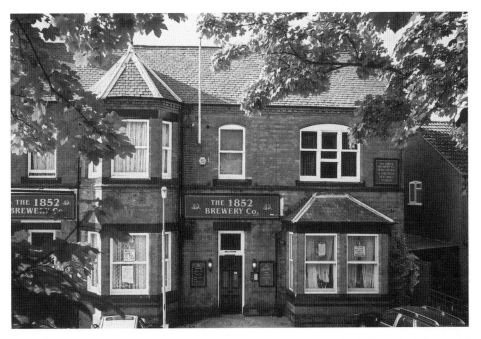

A modern photograph of what was the Railway Hotel in Station Road, which was built in around 1870 by the Midland Railway for the convenience of passengers. In 1877 Henry Bray held the licence and by 1888 it was held by William Ushwood. As can be seen, it is now trading under the name The 1852 Brewery Company.

The Shoulder of Mutton, Long Street, which stood on the site of the present 'Devil House' (see the dragon-type beast on the roof), c. 1912. In 1828 Joseph Cooper was licensee and was also a maltster. The same family held the property continuously until 1895 when it was demolished.

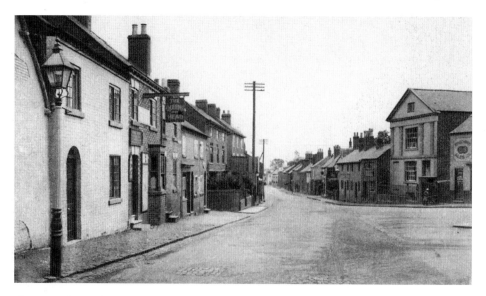

The Queen's Head, Bull Head Street, the second building along on the left, *c.* 1906. In 1846 William Vann was licensee. The pub was popular with societies and was headquarters to oddfellowes' lodges and cricket clubs for many years. It was rebuilt in a mock-Tudor style but retained some of the original buildings at the rear. Looking very sad at present as it awaits demolition.

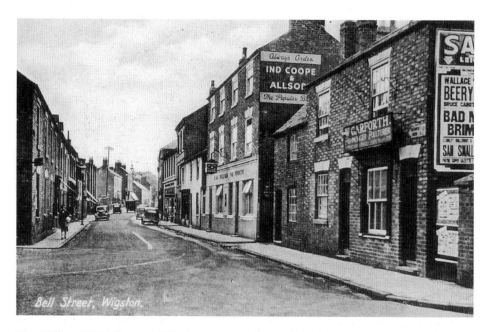

King William IV, Bell Street, *c.* 1930. It was opened about 1828 when George Goodwin held the licence, by 1854 it was John Goodwin. It was de-licensed in 1957 and the licence transferred to the Nautical William in Aylestone Lane. The building was then used for business premises until demolition in the late 1960s.

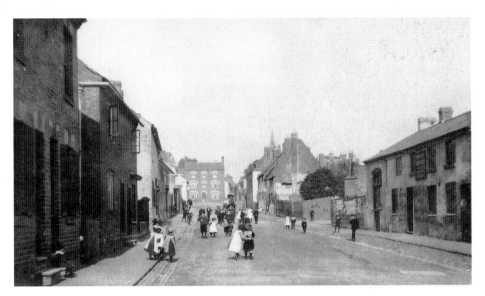

Travellers Rest, Bull Head Street, shown on the right of this *c.* 1905 photograph. It was strictly a beer house rather than a public house. In 1838 Joseph Burkitt – who was also a builder – held the licence, and in 1861 it was the Chamberlain family, followed by the Boothaways. It was demolished around 1910 and A.H. Broughton's hosiery factory built on the site.

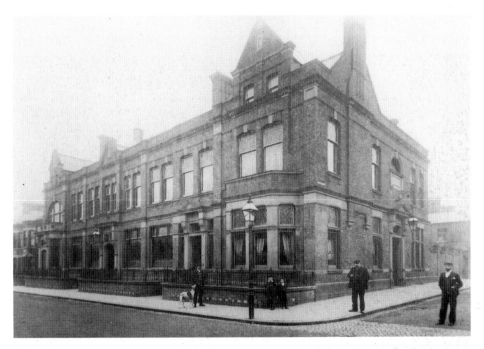

The Clarence Hotel, Blaby Road (seen here around 1920) was built by Orson Wright about 1890. In 1892 he is listed as the proprietor and Job Clarke is the manager. A large hotel which was said to have the longest bar in Europe, it was used for concerts, dances and early film shows. Gertie Gitana (see page 51) performed here and a room is named after her. The name of the hotel was subsequently changed to the Gaiety and is now the Marquis of Queensbury.

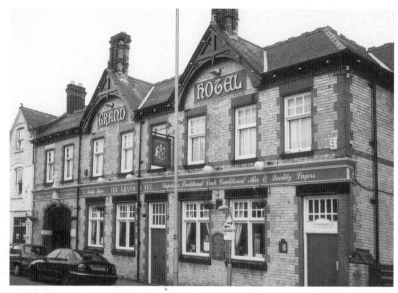

A modern photograph of the Grand Hotel, Canal Street. Like most of original South Wigston it was built by Orson Wright around 1886 and by 1888 Alfred Clark was the manager.

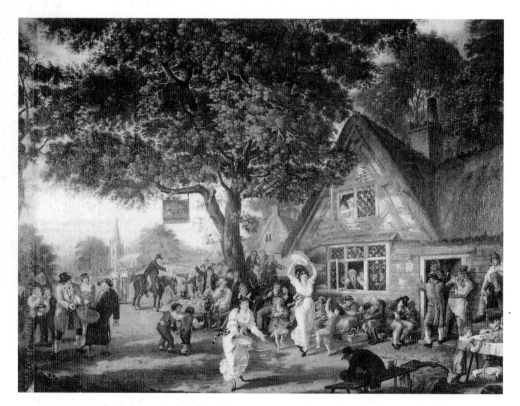

This picture, the earliest known image of Wigston, was painted in 1794 by John Kirk. It is a sort of cartoon and is thought to depict St Wistan's/Wolstan's Church and a group of merry locals celebrating the village feast. The pub building appears to be based on the Durham Ox (page 73), the old gable end in the painting being an earlier version which was replaced by brick and slate. Over the door the licensee's name is G. Guzzleworth!

# Leisure
# Activities

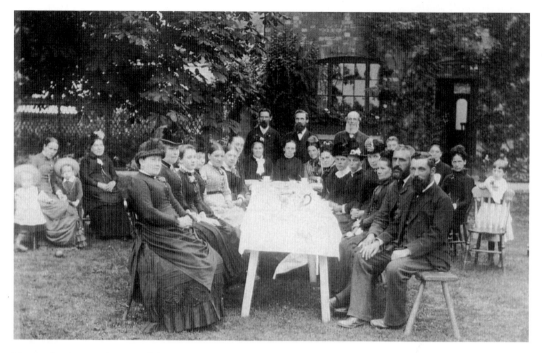

Tea on the lawn at the rear of the Congregational Church Manse in Long Street in the 1890s. The man with the white beard on the right of the group of three standing is believed to be the Revd Thomas Cope Deeming who had moved from near Sheffield to be pastor of the church in 1889.

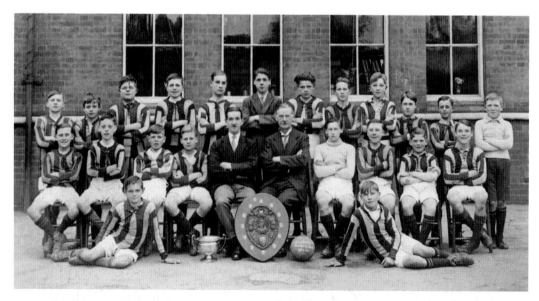

Wigston Board School football team division champions in 1927/8. The adults in the centre are left, Hylton Herrick (deputy headmaster) and right, Edgar Boulter (headmaster). Some of the children include: Harry Carter, Claud Allsop, Noel Smith, Jack Bradshaw, Jack Queenborough; other lads named were Harrison, Ross, Walden, Hackett and Findley.

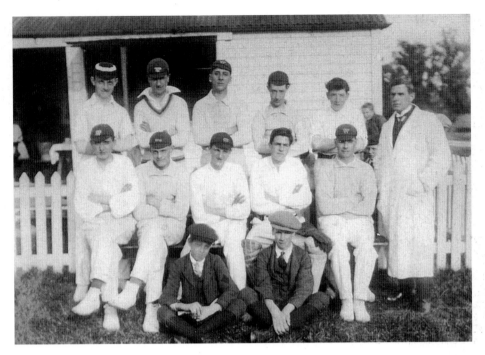

Wigston Primitive Methodist Cricket Club team pose outside their pavilion in Cottage Field to the east of Welford Road, *c.* 1920. From left to right, back row: Harry Broughton, Cyril Johnson, Arnold Carter, Alf Gamble, Arthur Getliffe, Ike Kirby (umpire). Middle Row: Ralph Kirby, Harold Crane, Billy Pymm, Ralph Merrick, Ernie Orton (captain). Front Row: -?-, Gerald Marlow.

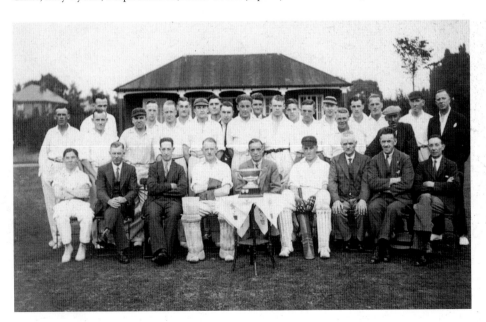

Willow Park Cricketers with their cup in the 1930s. From left to right, seated: G. Phillips, Orson Lucas, ? Gamble, Bob Kind, Bert Broughton, -?-, -?-, Billie Matts, -?-. Among those at the back are Reg Clark, Walter Boulter and Ron Elliott.

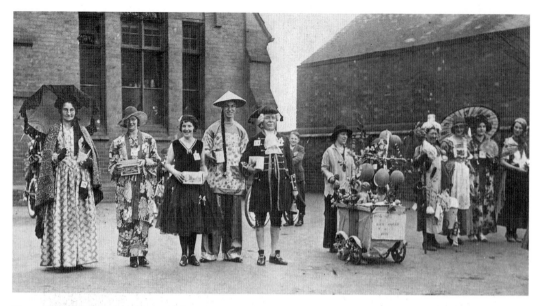

Photograph taken on the National School playground but unfortunately the event is unknown. Could it be a fancy dress competition as everyone has a numbered ticket pinned to their costume? The two men in the centre are Bill Penney (left) and Philip Sampson (right).

Bell Street School, c. 1930. Each child proudly showing off a toy, which was either a prize or one they had been allowed to bring from home for a special reason. From left to right, back row: Norman Boulter, Freda Copson, Dennis Hougham, -?-, Jack Thornton, Nancy Markham, Ralph Jebbett. Middle row: Dennis Hackett, Marian Lucas, -?-, -?-, -?-, Marie Thacker, Harry Granger, Jean Mason, -?-, Maurice Dixey. Front row: Kath Thornton, Marion Boulter, -?-, Audrey Lucas, -?-, -?-.

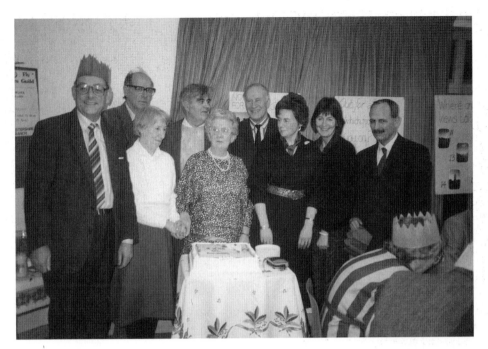

Members of Greater Wigston Historical Society gather to celebrate their tenth birthday in 1990. From left to right: Brian Bilson, Jim Colver, Edna Taylor, Bob Wignall, Doris Chandler, Duncan Lucas, Tricia Berry, Chris Smart, Mike Ward.

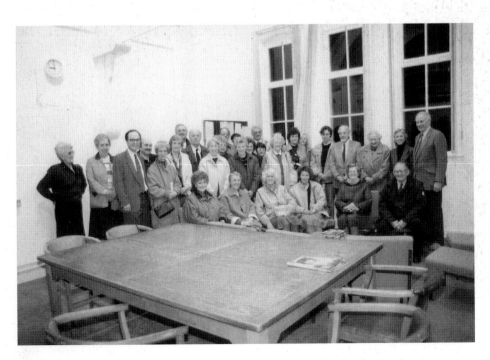

The Society paid a visit to Leicestershire Record Office in 1993 shortly after its relocation to Wigston. Third left is Dr Carl Harrison, County Archivist.

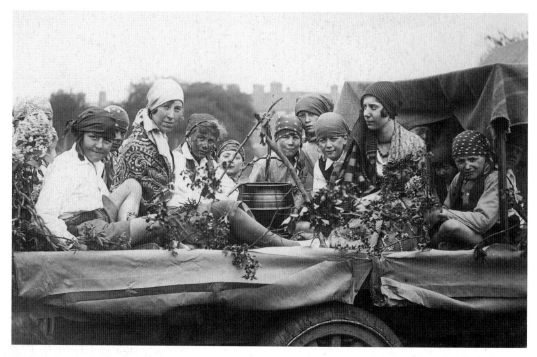

A South Wigston Sunday school parade on 24 May 1930. Can anyone identify any of these gypsy girls for us?

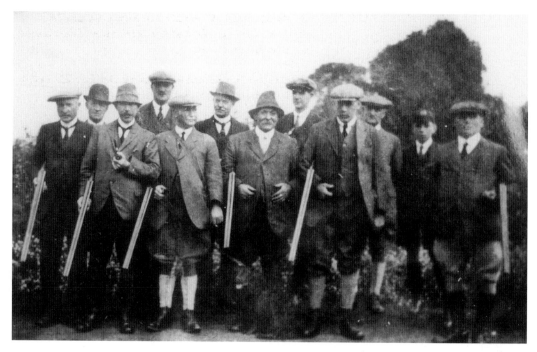

A group of friends out on a shoot, c. 1922. From left to right: Arch Wilde, -?-, Ernest Broughton, Bob Jones, Walter Mason, Sam Laundon, Tommy Judd, -?-, Albert Shipp, 'Kipper' Broughton, Edwin Broughton, -?-.

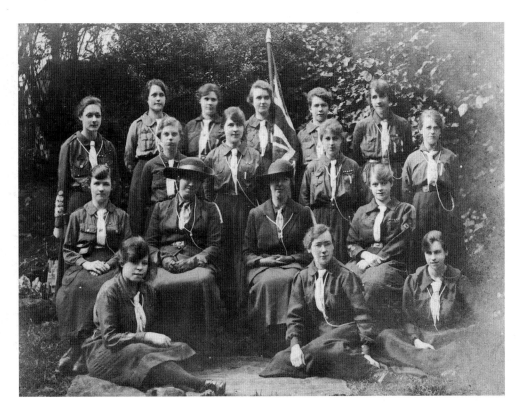

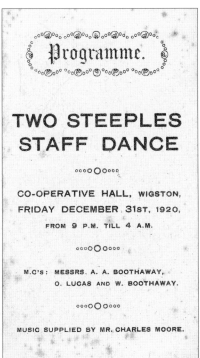

*Above:* Girl Guides in the 1920s. Kitty Ross, later Kitty Smith, daughter of Alfred Ross, headmaster of the National School, is on the left.

*Left:* Two Steeples Ltd staff dance on New Year's Eve 1920. Note the event did not finish until 4.00 a.m!

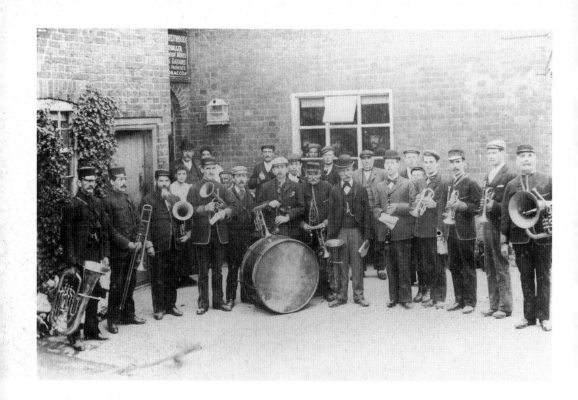

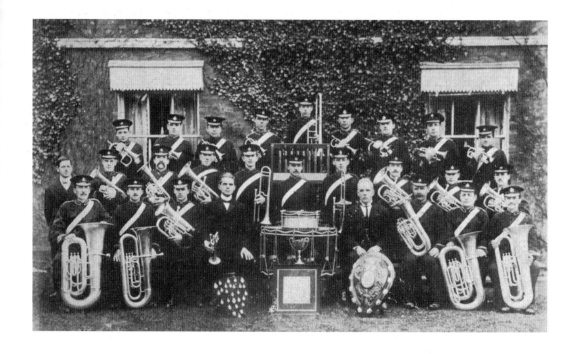

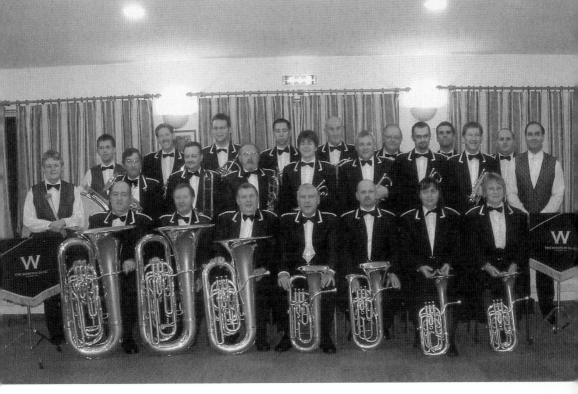

A 2003 line-up of the present Wigston Band taken at Goodwood Bowls Club. From left to right, back row: R. Marvin, P. Hales, I. Hayto, M. Lee, P. Harris, N. Spence, P. Edwards, K. Turner. Middle row: M. Horsburgh, M. Stowe, B. Campbell, A. Chilver, K. Edwards, G. Shaw, S. Jackson, G. Higham, G .Sleath (musical director). Front Row: C. Raggett, D. Wadey, D. Spray, P. Spray, T. Mills, S. Hayto, W. Burke.

*Opposite above:* The Wigstons had, and still do have, a fine brass band tradition. This group taken in about 1890 were members of Wignall's Band. From left to right, front row: George Herbert, George Ludlam, Ben Wignall, Albert Wignall, Joe Wignall, -?-, William Wignall, -?-, -?-, -?-, ? Hurst, ? Sturgess, William Henry Wignall. The unnamed people are believed to be support from another band.

*Opposite below:* The Temperance Silver Prize Band posing with their shields and trophies, *c.* 1905. On the left behind a shield is Charles Moore (leader) and on the right behind the other shield is John D. Broughton (president). The band still plays today under the updated name of The Wigston Band.

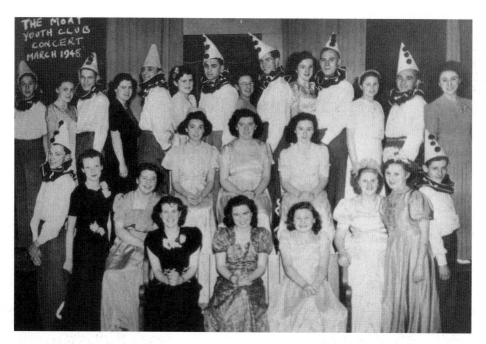

Wigston Methodist Youth Club Concert, March 1948. From left to right, back row: Denvil Orton, June Bishop, David Thomas, Dorry Wilford, George Austin, Pearl Orton, Ray Bishop, -?-, John Rawson, -?-, Trevor Johnson, Margaret Jarvis, Bernard Kirby, Barbara Johnson. Sitting centre: Marjory Throop, -?-, Dorothy Cox. Front row: Jack Russell, Ann Mould, Mira Sharman, Betty Hassell, Joan Smith, Janet Sharman, Hilda Silverwood, Pat Flint and Phil Cant.

Before the National Health Service, annual parades were held to raise money for the Leicester Infirmary. Competition for the best floats could be intense. This photograph (c. 1905) shows Mr Wright, Wigston's last horse carrier, with his horse, both smartly turned out and employed in duties altogether different from a normal day. Unfortunately the names of the flower girls are not known.

Another carnival procession, this from the 1930s. Here Wigston Temperance Silver Prize Band leads the way while following in white is Arthur 'Pickler' Preston, dressed as Gandhi. With the aid of cocoa and the appropriate clothes he walked barefoot and without his teeth through Wigston leading a goat. He was so realistic it caused a sensation and was long remembered by those who saw it.

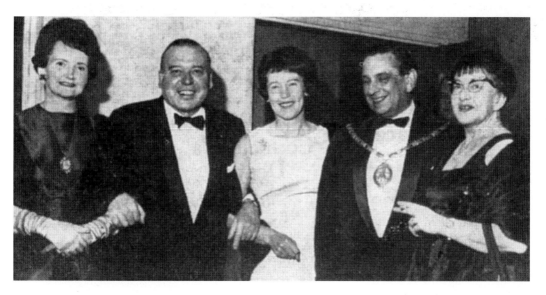

Wigston Women's Luncheon Club at their annual dinner at the Glen Inn, Glen Parva, c. 1967. From left to right: Mrs Tewkesbury, Eric Robinson (band leader and television personality who was guest speaker), Mrs J.B. Durrant (speaker's secretary), Councillor D.J. Tewkesbury (chairman of Wigston UDC), Mrs M. Armitage (chairman).

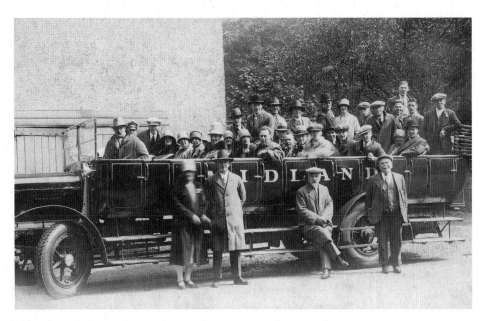

Employees of Wigston Co-operative Society enjoying their works outing in the late 1920s.

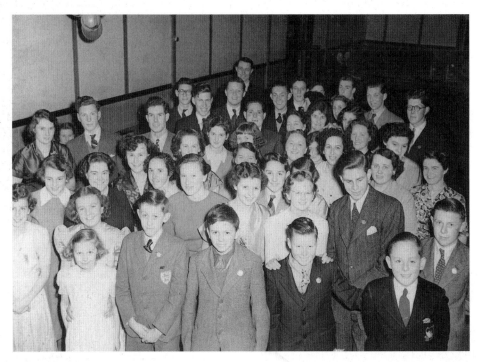

Wigston Young Farmers' Club at their first social in the Constitutional Hall, Cross Street, 1952. From left to right, front row: Ann Heard, Ruth Hall, Bryan Hall, –?–, John Munton, John Freckingham. Others behind include: Doris Wilford, Jean Allen, Duncan Lucas, Jean Kendall, Roger Hill, Janet Warsop, Richard Rawson, Edwin Bale, John Rawson, Betty Johnson, Patsy Pask, James Forryan, George Bailey, Michael Bale, Alan Thornton and Oswald Johnson.

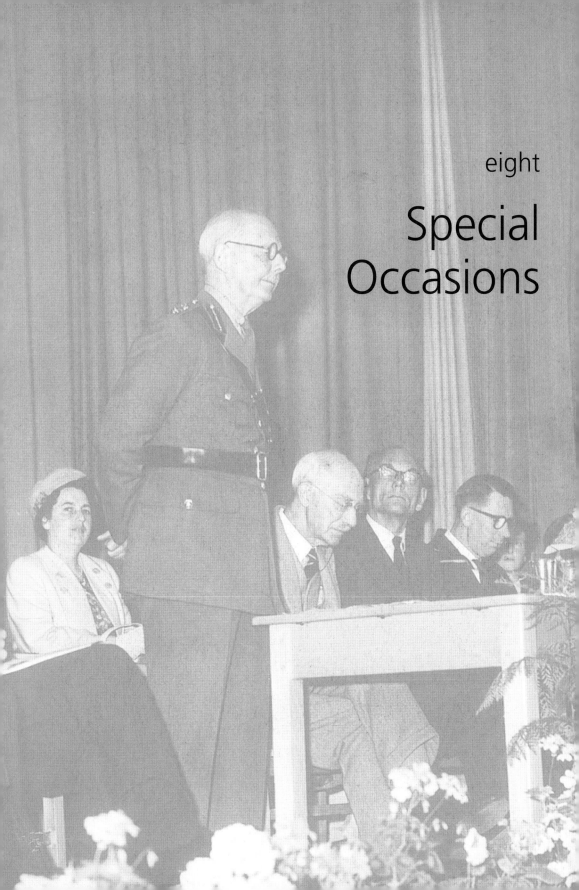

# Special Occasions

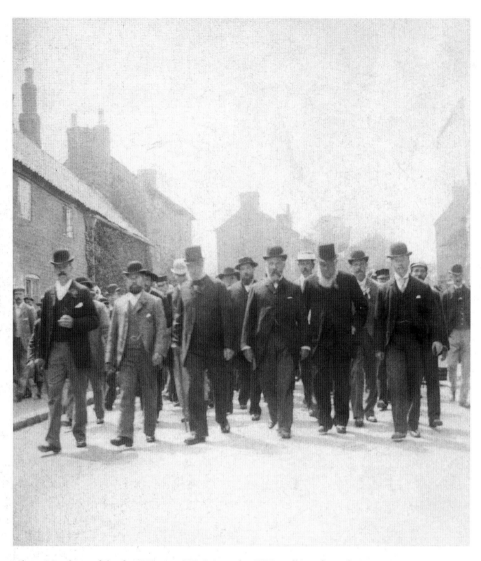

*Above:* Members of the first Wigston UDC in early 1895, walking from their previous meeting place at the National School to their new one at Bell Street School. From left to right, front row: Francis H. Freckingham, William G. Forryan, -?-, John D. Broughton, Hiram A. Owston (probably), -?-. Other members of the council who would be in the group were: Thomas H. Johnson, John Snowden, John Walker, John Cooper, George Ross, Henry J. Barwick, William Dunmore, Orson Wright, John Bruce, Arthur Moulds and Richard H. Warren.

*Opposite above:* Wigston UDC received its own coat of arms in around 1952. At the presentation ceremony are, from left to right, standing: Ted Wright (deputy clerk), ? Hanrahans, Jack Brooks, Herbert Garratt, N.W. Warsop, Roy Cooper, Joy Mehan, Walter Boulter, -?-. Sitting: William Gunning (clerk), Ethel Thornton, Eddie Rawson and Ernest Forryan.

*Opposite below:* Canon George Henry West, vicar of All Saints, died aged fifty-seven in December 1956. Here his funeral procession, having just passed the crossroads, makes its way along Welford Road towards the cemetery.

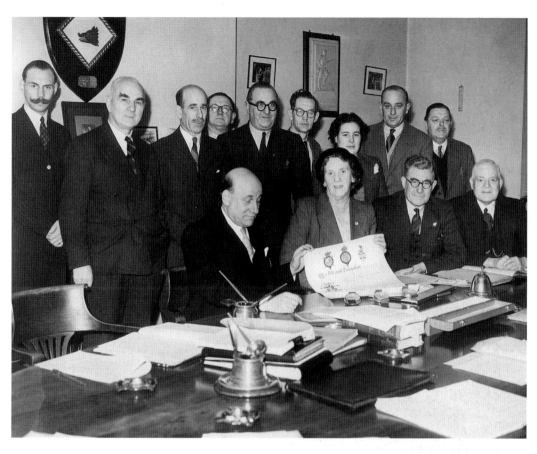

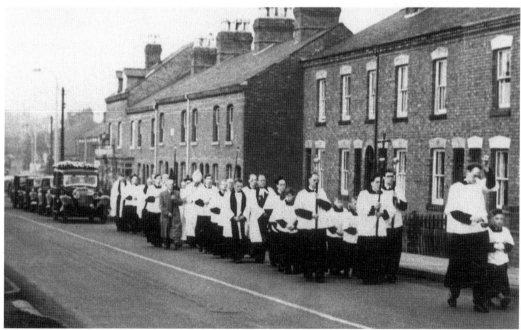

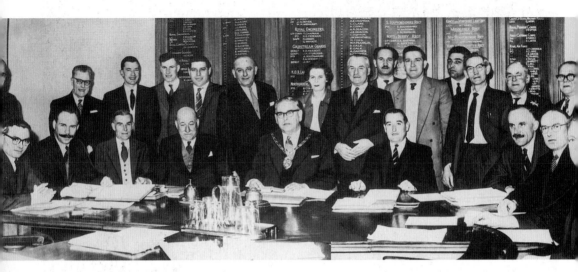

Councillors and officers pictured in 1961 are, from left to right, standing: Jack Brooks, ? Simpkin, Jack Russell, Duncan Lucas, Frank Berry, Walter Boulter, –?–, Curtis Weston, Jerzy Klinger, Eddy Allsop, Gordon Wilkins, Roy Cooper, Leslie Forryan, Harry Whitehead. Sitting: Colin Wragg (treasurer), Ted Wright (deputy clerk), Tom Bambury, William Gunning (clerk), Osmond Hilton (chairman), Don Mobbs., Fergus Isherwood (surveyor), –?–, –?–.

*Opposite above:* Officials and choir of All Saints Parish Church, *c.* 1927. From left to right, back row: Fred Rowe, Will Beatty, Ted Hill, Horace Moore, ? Chadderton, Leslie Ford, B. Walden, ? Whitehead, Arthur Ladkin, D. Taylor. Third row: Alan Sibson, Gordon Bowers, John Anker, –?–, –?–, Ron Seaton, ? Hallet, Jack Gibson, G. Huckle, Kenneth Bowers, D. Sibson. Second row: Colin Bowers, Violet Moore (organist), ? Harrington, the Revd N. Hony (curate), Canon T.W. Wright (vicar), Mr Lammiman, H. Moore, the Revd Blackett, F. Robson. Front Row: J. Vann, H. Keeley, ? Mould, ? Dixey, ? Hillman, Edgar Vann.

*Opposite below:* Platform party at the opening of Abington School on 31 May 1957. From left to right: Curtis Weston, (vice-chairman), Eddie Rawson (chairman), Mrs Milner, Sir Robert Martin (lord lieutenant), Lord Cromwell (deputy lieutenant), Mr Mason (director of education), Mr Milner (headmaster), Emma Rawson.

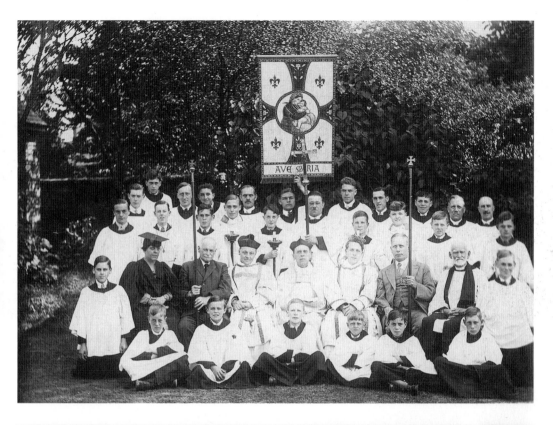

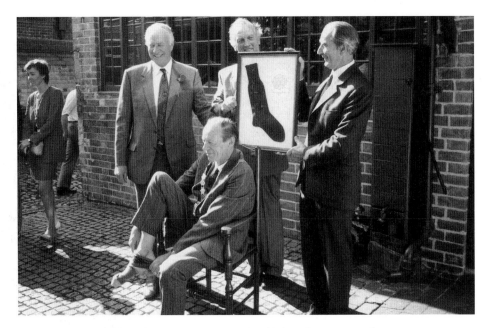

Wigston Framework Knitters Museum hosts a colourful annual ceremony when a peppercorn rent of one knitted sock (since risen to two!) is presented by the Trustees to Oadby & Wigston Borough Council. Shown here in 1992 are, from left to right: Ruth Hyde (chief executive of Oadby & Wigston Borough Council), Duncan Lucas (chairman of trustees), Peter Clowes (curator), Sir Timothy Brooks (lord lieutenant and president of trustees). Sitting: Dave Allen (mayor of Oadby & Wigston Borough Council), receiving the rent and about to try it on for size!

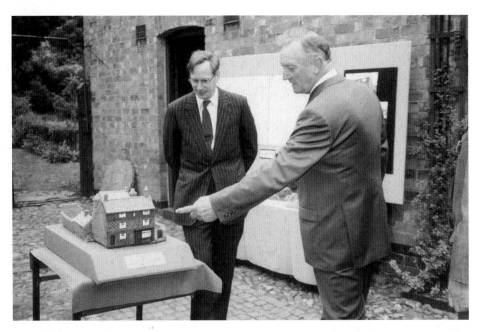

In 1993 the museum was honoured to receive a visit from HRH the Duke of Gloucester. Here Peter Clowes points out one of the items on display, a beautifully worked scale model of the site.

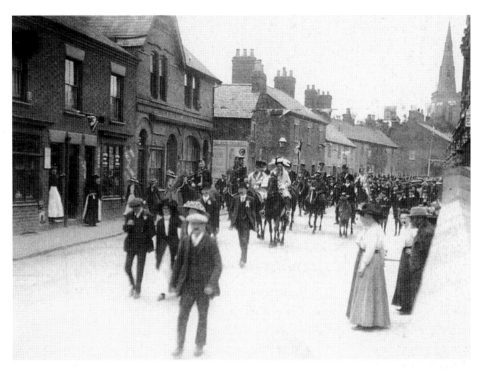

This procession formed part of the celebrations held for the Coronation of King George V and Queen Mary in 1911. All Saints Church can be seen far right and the wall in the foreground belongs to Avenue House on the corner of Central Avenue.

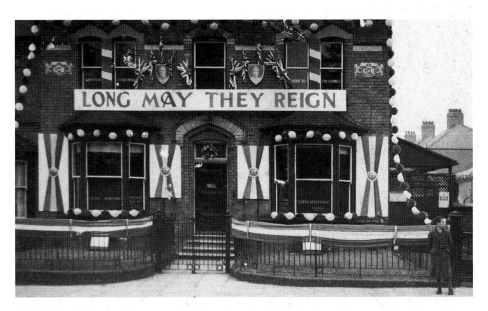

This large property on the corner of Pullman Road and Station Road has served as a school, police station and probation office, but in 1937 it was the council offices and had been beautifully decorated for the coronation of George VI and Queen Elizabeth.

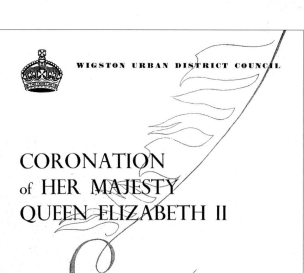

# WIGSTON URBAN DISTRICT COUNCIL

## CORONATION
### of HER MAJESTY
### QUEEN ELIZABETH II

*Souvenir Programme*

CONTAINING THE FULL PROGRAMME OF CELEBRATIONS PLANNED FOR CORONATION WEEK AND INCLUDING ARTICLES ON THE HISTORY OF WIGSTON PERSONALITIES, SPORT AND OTHER INTERESTING FEATURES

PRICE ONE SHILLING

*Left:* Front cover of a souvenir programme of events organised by the council to celebrate the coronation of Queen Elizabeth II in 1953.

*Below:* The centre spread of the programme showing entertainment arranged for the day.

## Programme of Coronation Day Activities
Chairman of Coronation Committee H. J. GARRATT, Vice-Chairman W. MATTS

The day opens with Anglican and Roman Catholic Churches Holy Communion and Mass. PEALS OF BELLS rung at the churches of All Saints' and St. Thomas'.

**9 a.m. Glen Parva Barracks** — CORONATION PROCESSION AND CARNIVAL will assemble at Glen Parva Barracks, by kind permission of the Officer Commanding. The VEHICLE PROCESSION comprises 3 groups—Historical, Humorous, Commercial. Entrance forms obtainable at the Council Offices and must be returned not later than Friday, May 29th. Leaving the barracks the procession will take the following route—Saffron Road, Blaby Road, Pullman Road, West Avenue, Holmden Avenue, Aylestone Lane, Bell Street, Bull Head Street, Moat Street, Bushloe End.

**9.30 a.m. Processional Route**

**9-45 a.m. Bushloe House** — WALKERS' PROCESSION, comprising 3 groups—Historical, Humorous, Original—for adults and children (single, pairs or groups). Entries taken on day. Assemble at Bushloe House and headed by the Wigston Temperance Silver Prize Band, the Carnival Parade will lead the procession to "Abington", Station Road, arriving in time for the commencement of the

**"Abington"** — OX ROASTING. The Chairman of the Council will light the fire and from here on its

**11 a.m. Sideshows** — ALL THE FUN OF THE FAIR, with plenty of fun at the Nursery Playground with Roundabouts, etc., for the young, Long Alley Skittles for a Pig and a Barrel of Beer. Table Skittles with Ladies' and Gents' prizes. Spinning Jenny. Treasure Hunt with £1 reward. Darts with Nylons for the Ladies, a case of Beer for the Men and various other prizes. Devil-among-the-Tailors and a prize for the highest scores. Revolving Darts gives a prize every time. Roll-a-Penny Table. Coconut Shies. Hoop-La, Racing, etc. Be sure and visit this Wonderland of Fun.

WIGSTON TEMPERANCE SILVER PRIZE BAND will play selections during the day.

**11-15 a.m. Presentation Comic Football** — Presentation of Prizes to winners of Fancy Dress and Decorated Vehicles and COMIC FOOTBALL MATCH will be played by the South Wigston Old Boys' R.F.C.

**12 noon to 12-45 p.m.** — As a prelude to the relaying of the ceremony of the Crowning of Her Majesty Queen Elizabeth II, the side-shows will close and a short service of dedication will be held.

RELAY FROM THE ABBEY CHURCH, WESTMINSTER, OF THE CROWNING OF OUR MOST GRACIOUS SOVEREIGN LADY, QUEEN ELIZABETH II, by the Grace of God Queen of England, Scotland, Wales and Northern Ireland, Head of the Commonwealth, Defender of the Faith.

**1 p.m. Funfair and Sports** — FUNFAIR RE-OPENS. Impromptu sports for adults, and a tried and trusted favourite PUNCH AND JUDY SHOW by "Robbo".

**2-30 p.m. Baby Show** — MAMMOTH BABY SHOW. Entries taken on day. Group (1)—up to 6 months; (2) 6-12 months; (3) 12-18 months. Special section for twins and numerous prizes will be awarded.

**3 p.m. Community Singing** — COMMUNITY SINGING for young and old led by the Wigston Temperance Silver Prize Band, directed by Mr. E. C. Moore, with Youth Organisations, and it is hoped that children of all ages will gather round the bandstand and join in song.

**3-30 p.m. Competitions** — ANKLE COMPETITION for all Ladies over 15 years of age, will be followed by a KNOBBLY KNEE COMPETITION for men over 15 years of age. Suitable prizes will be presented and there is a special competition for the MOST ATTRACTIVE LADIES' HAIR and the SMARTEST GENTLEMAN'S HAIR.

**4 p.m. Folk Dancing Square Dancing** — Master of Ceremonies, Mr. Joyce, presents a display of FOLK DANCING, followed by SQUARE DANCING for everyone, and a Concert by The Wigston Temperance Silver Prize Band, specially selected to suit your taste.

**6 p.m. Judo** — DISPLAY OF "JUDO" by members of the Leicestershire and Rutland County Constabulary.

**7 p.m. The Roasted Ox** — SERVING OF ROASTED OX. Mr. Frank Freer, who donated the Ox, will carve the first slice, after which slices will be available to the public.

**7-30 p.m. Pageant of Wigston** — THE PAGEANT OF WIGSTON, devised and written by William Hall and Audrey Walpole, will give incidents in the 1400 years' history of Wigston. Wigston has a very interesting and ancient history and up to about 1540 comprised only of timbered dwellings clustered about the two churches and a moated house built of rubble masonry, situated at the bottom of Newgate End. The Pageant has been devised and written after much research through old records, and brings to life scenes that were enacted in the village from 500 A.D. to 1899. There are six episodes, chosen as interesting features in Wigston's history, and being the most populous village on the boundaries of Leicester, in those early days contributed much to its prosperity. Full details of these interesting episodes will be given in a separate programme. A limited number of seats at 2/6 may be booked at Mrs. Wray's, 13 Blaby Road, South Wigston.

Relay of the Broadcast Speech of HER MAJESTY QUEEN ELIZABETH II.

**10 p.m. to Midnight Dancing** — All invited, young and old, to take part in OPEN AIR DANCING with Master of Ceremonies, Mr. Joyce. If the weather should be wet dancing will take place at the South Wigston Modern Schools, Blaby Lane, South Wigston, from 8 p.m. to midnight, admission free.

**10-30 p.m. Fireworks** — GRAND FIREWORK DISPLAY. MIDNIGHT—NATIONAL ANTHEM.

**In addition Television** — In addition to this programme of events arranged at "Abington" for Coronation Day, the Magna Cinema (by the generosity of Messrs. Cockroft Brothers) will be open to the general public throughout the televising of the Coronation Procession through London and the Service from Westminster Abbey on a special screen.

In addition to the programme of events listed above there is also a full week of entertainment starting on May 31st and ending with a Grand Sports Day on June 6th. Full details of these events are listed on the previous page.

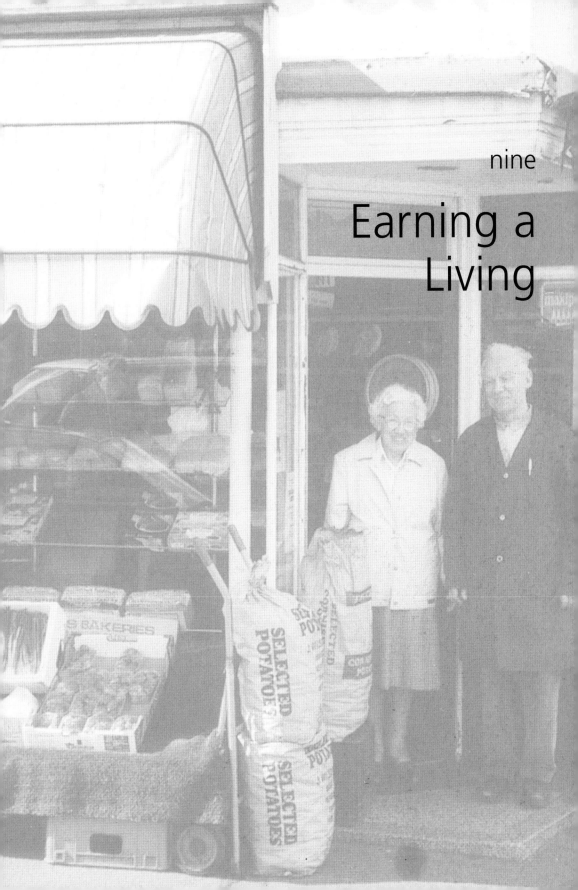

# Earning a Living

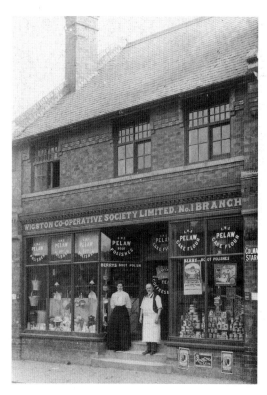

Wigston Co-operative Society's No. 1 branch, *c.* 1902. This was situated on the corner of Moat Street and Cedar Avenue, and the manager was James Whyatt. It had been opened in about 1890 and sold grocery, footwear, hardware and drapery items.

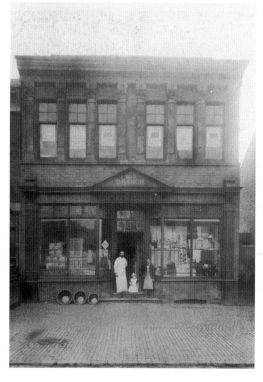

Wigston Co-operative Society's No. 2 branch in 1897. This was situated in Blaby Road and the manager was George William Bass. It had also been opened around 1890 and sold grocery and drapery items. Note the cobbled street and pavement.

C.R. Hardy, grocers and provision merchants, with their delivery vehicle, *c.* 1910. Charles Richard Hardy had opened his business in Long Street about 1894, taking his son into partnership by 1925. By 1936 the business was named Hardy Brothers and had opened a second branch at 2 Moat Street. It did not close until the early 1960s.

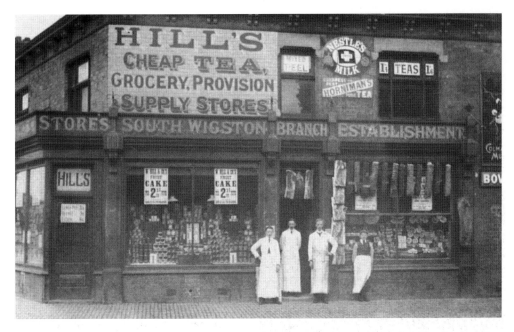

William Hill's grocery and provision store in Canal Street, *c.* 1912. This was quite a large company with nine branches in Leicester and one each in Clarendon Park, Aylestone Park, Syston and Bull Head Street (page 11).

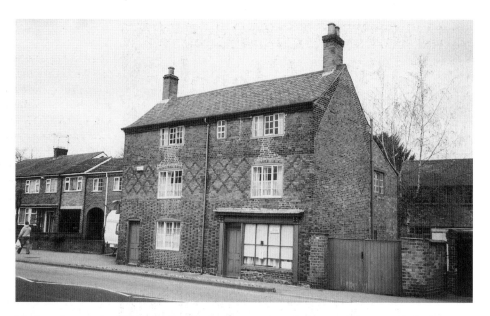

Modern photograph of 42/44 Bushloe End, now a museum, the best surviving example in the county of a master hosier's house and workshop. The business had been established by Joseph Trueman who moved to this address in 1880. After his death it was continued by his son-in-law Edgar Carter until 1948/9. Two of Edgar's daughters remained in the family home and retained the machinery, hence the time capsule of today. The two-storey building was originally of early eighteenth century, thatched, and built on an even older rubble foundation. The top floor and long lean-to workshop against the back were added around 1850.

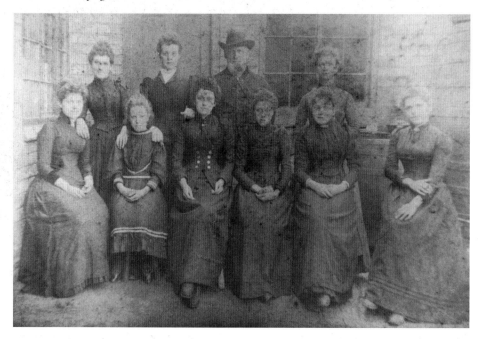

Joseph Trueman's workforce, c. 1894. He is standing at the rear while seated first left is Elizabeth Forryan and first right her sister Adah Forryan.

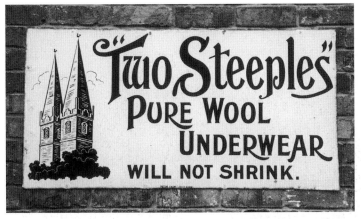

Metal wall sign for Two Steeples Ltd, the largest hosiery company in the area. Founded by Ambrose Lee in around 1850, it eventually became part of Mansfield Hosiery Mills before closing in the 1980s. The factory site in Leicester Road has recently been cleared and awaits the erection of sixty homes.

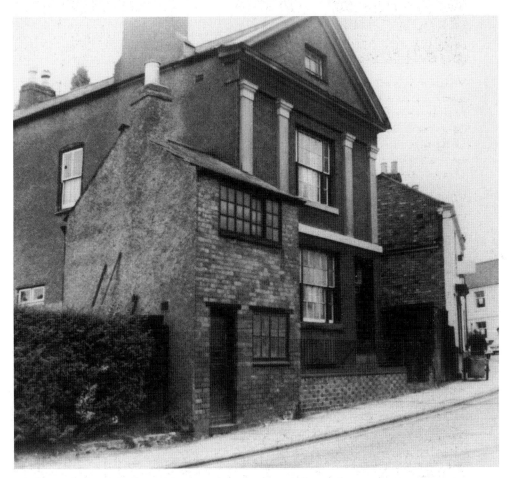

The tall building in this 1960s photograph is believed to have been built as a Quaker chapel. In 1840 it served as a Mechanics Institute and by 1846 was opened as a British School for 100 nonconformist children. These were transferred to Bell Street School in 1873. Thereafter it was used as a private house by the Snowden family. The little workshop in front was used for their needle-making business which had traded in Wigston from about 1815 until the 1920s and '30s. Both were demolished in the early 1970s.

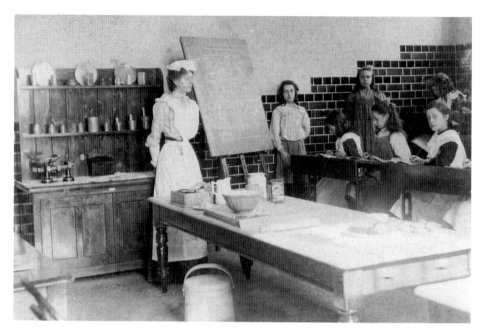

Margaret Matthews taking a cookery lesson at South Wigston Girls' School on 16 June 1904. She was a subject specialist and travelled to different schools. The pupils are copying down a recipe for fruit pudding with suet pastry from the blackboard. Margaret was the daughter of Samuel B. Matthews (see page 32). She trained at Leicester Cookery College which was situated in the old Guildhall at the time.

Cook & Hurst factory girls pose around 1900 outside a house in Long Street which stood where the Co-operative Headquarters was later built. Second left, seated, is Maggie Lucas. Messrs Cook and Hurst were ex-employees of Two Steeples who decided to set up on their own. They soon moved further along Long Street into a purpose-built factory and the business continued under the name Admiral Sportswear until recent times.

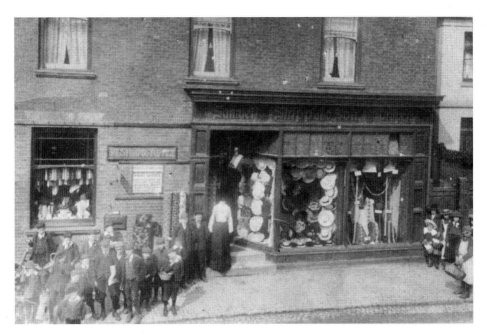

Samuel Shipp & Son's Bell Street linen and woollen drapery business, *c.* 1904. At this time Samuel was also sub-postmaster for the village and operated this business from the same premises. Customers had to walk through the shop to reach the post office counter. In addition to the shop, Shipp's ran a mobile service visiting outlying villages.

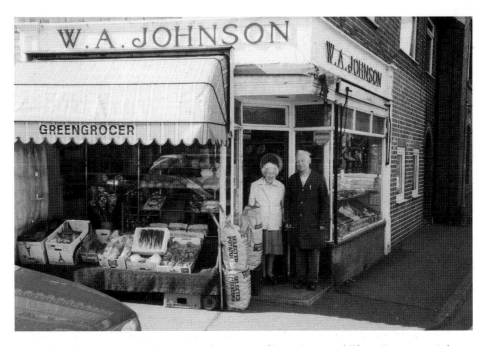

W.A. Johnson's greengrocery business on the corner of Long Street and Blunts Lane occupied the site of the old Durham Ox Inn. It had traded from at least 1941 until 2003. This photograph shows Brian Johnson on the final day of trading with the last customer, Olive Bowers.

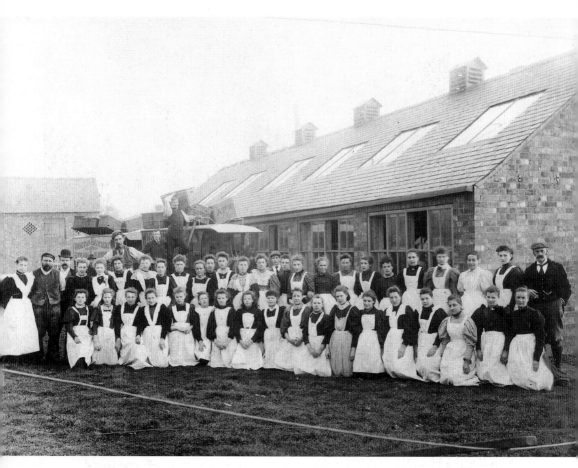

Wigston Laundry staff, *c.* 1895. From left to right, behind: W.H. Vann, Tom Busby (or Buswell), William Norman, J. Cawthorn. Standing: Miss Hitchen, T. Judd (foreman), H.W. Tharp (owner), Miss Sharp, Emma Mould, Rose Allen, Cissie Barnett, Annie Vann, Sarah Williams, Sarah Snutch, Pat Boulter, Nellie Owen, Carrie Bennett, Betsy Grieves, Albert Roberts, Hattie Herbert, Kitty Kirby, Mrs Bailey, Rose Lewin, Sarah Cawthorne, Rose Plowright, Clara Lewin, Agnes Allen, Mrs Trueman, Miss Lawler, E.S. Crowe (partner). Kneeling: Nellie Herbert, Hilda Sharpe or Winnie Greasley, Ada Roberts, Eva Hurst, Annie Harding, Florrie Dare, Aggie Smith, Gertie Smith, Gertie Judd, Polly Holiland, Lucy Smith, Mabel Sharp, Edith Waldon, Evelyn Gamble, Aggie Holt, Lucy Yorks, Liza Hickton, Maria Lewin.

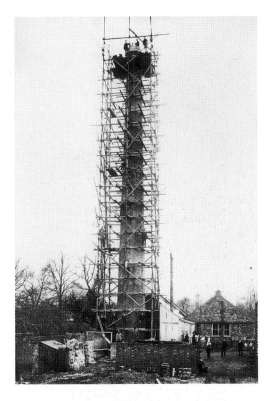

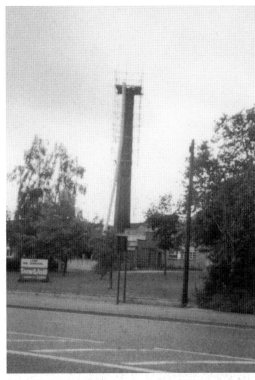

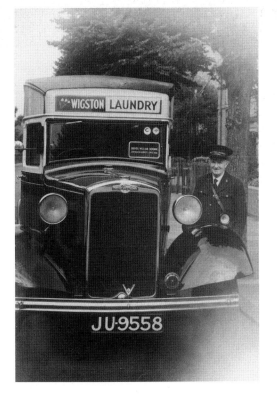

*Above left:* Going up. The laundry in Bull Head Street had been established in 1892 and by 1895 had expanded to employ all the staff on the previous photograph and build their well-remembered chimney. At this topping-out ceremony people can be seen on the ground, at first and sixth level, and three brave builders right at the top.

*Above right:* Coming down. The laundry merged with Belgrave Laundry in 1982 and left Wigston. The redundant chimney was eventually demolished and B & Q now occupy the site.

*Left:* Driver William Norman – seen on the group photograph as a young man – is by this time, in the late 1920s, a middle-aged man. A sign in the window of his Morris Commercial van records his continuous service since 1892. Note the snowdrop logo above the windscreen.

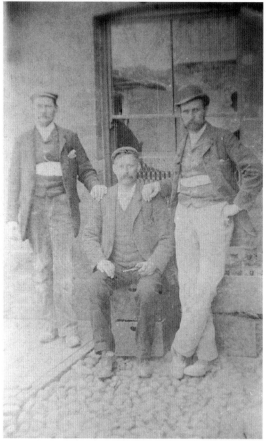

*Above:* Four businesses seen here in the 1920s. The far shop was the Wigston Gas Showrooms, next the post office, then F.A. Brittain a tailor, and nearest the camera is Alfred King the chemist.

*Left:* Three stonemasons pose outside the Durham Ox in the 1890s. The one on the right is Henry George Lucas, grandfather of Duncan Lucas. He worked on the barracks and Grand Hotel, Leicester, and carved many of the tombstones in Wigston cemetery. Note the special aprons round their waists, these are in the tied-up position, but were unfurled and used to hold tools when working.

ten

# Farmhouses and Rural Matters

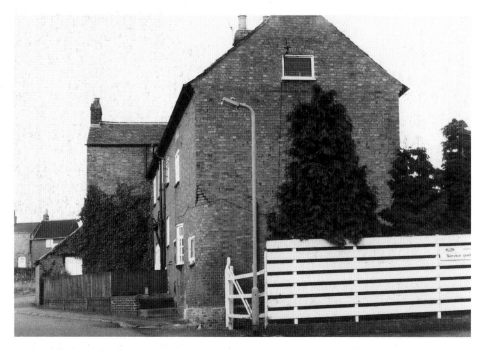

Modern photograph of Upper Farm House, Spa Lane, probably built early in the 1700s. Note the interesting brickwork on the corner, rounded at the bottom to deflect knocks from turning wagons, changing at first floor to normal square edge. It was still a working farm until the early 1960s, when Graham Gardner moved to the Cotswolds. It is now occupied as a private house. Note the cottage on the extreme left further up the hill which is an old Wyggeston Hospital property.

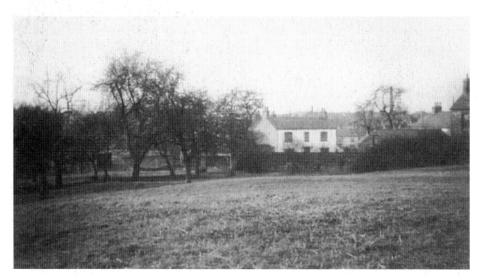

A 1950s view of the front of the same property which was added in 1741 (from the date stone under the creeper on the previous picture). It is taken from the top of the orchard where Shearsby Close has since been built. This part has long been a separate dwelling known as The Chestnuts, after two huge chestnut trees in the garden which had to be felled in 1940s as they became unsafe. Arthur Lee, managing director of Two Steeples, lived there in the 1920/30s.

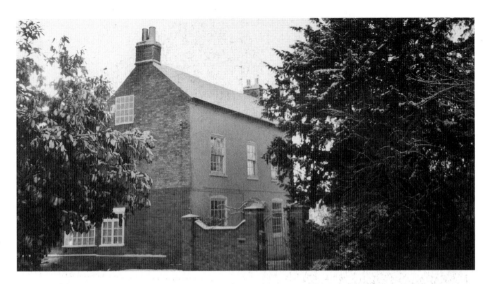

A recent photograph of Yew Tree House, Newgate End, which is Grade II listed and thought to date from the 1790s, with the upper floor added/replaced perhaps about 1820. The yellow bricks used were not made locally and were probably brought from London by canal. Bought in 1822 by John Blunt, a surgeon and proprietor of a lunatic asylum, it remained in his family's ownership until 1905 when it was purchased by W.J.R. Pochin from the Manor. It is now a private residence.

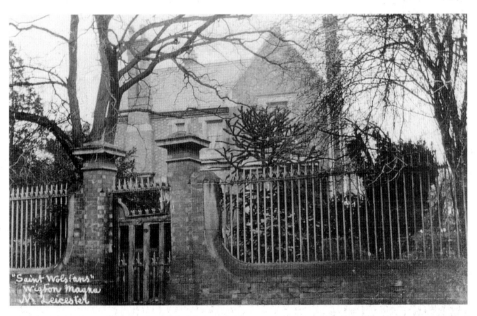

A 1920s photograph of St Wolstan's House, Church Nook, which was built in 1856, replacing an earlier house with extensive cellars on the same site. The estate had been purchased by William Morley, a Nottingham lace manufacturer, in about 1838 when it was occupied by the Eggleston family. It remained in Morley ownership until William's grandson, also William Morley, died in 1940. During the Second World War it served as a Civil Defence HQ. Today (2005) it is still a private dwelling. The house and its land were separated when the last Mr Morley retired and the farm was then run by others, notably in the 1950/60s by Eric Hall, who lived at 2 Bull Head Street.

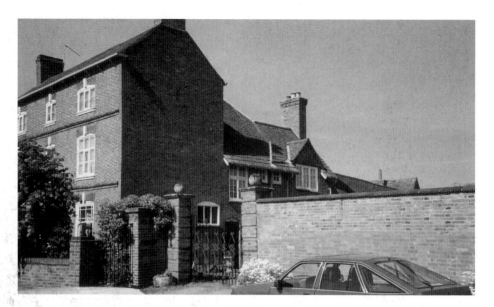

A recent photograph of the Manor House, Newgate End, which was built as a farmhouse by the Pochin family probably during the 1750s and continued in the same family until the death of W.J.R. Pochin in 1930. The land was later farmed by the Freckingham family and the house remains as a private home today.

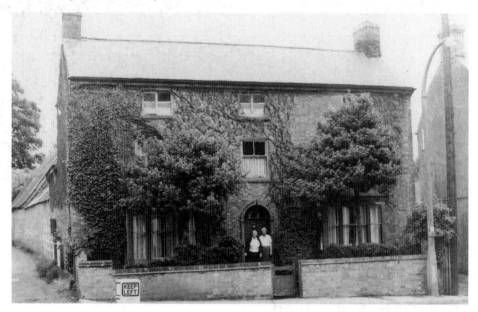

Firs Farm House, 16 Bull Head Street, was built during the 1750s. The land was farmed by James Tabberer in 1892 and Charles A. Willett from at least 1925, and then by his son Charles George Willett. George was gassed during the First World War, leaving him disabled. He was the last farmer in Wigston to use a horse and cart. The council condemned the property in 1974 and George died the day after being notified of this. The ladies outside photographed at this time are Mrs Knight, his sister, and friend Dorothy Page, who both also lived at the property. The site is now a track to Boulter Crescent.

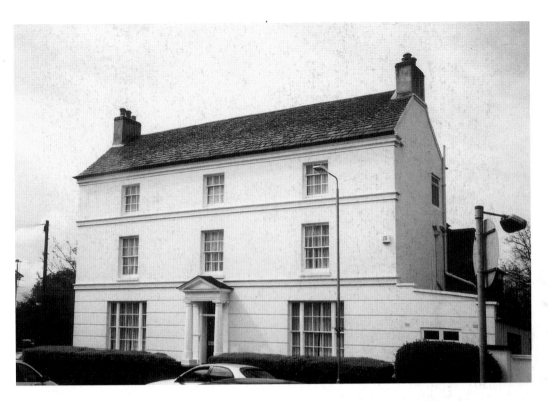

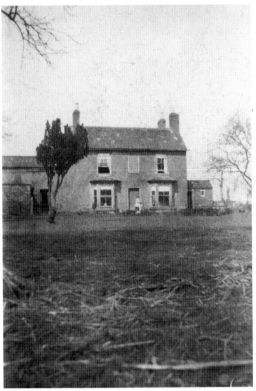

*Above:* A modern photograph of the Manor House, Long Street, which was built side-on to the road probably in the early 1700s and with a smart early eighteenth-century front added about 1820. It was long the home of the Ragg family until the death of John Ragg in 1838, when the property was inherited by a nephew, Robert Hames. Thereafter the house and its land were separated, with the house being let and eventually bought from that family. Dr James D. Hulme lived there in 1877, Dr John M. Longford from the 1920s and his son Dr Patrick F. Longford from the 1940s. Today it is a private home.

*Left:* Crow Mill Farmhouse, Countesthorpe Road, together with Crow Mill and surrounding land, was bought by David Orange, *c.* 1855. David had previously been a lambs' wool manufacturer in Leicester and lived in New Walk. Orange Street is named after him. His daughter Ann married Frederick Bates, a brewer, and they became the parents of the well known South Wigston artist H. W. Bates. In 1881 Peter Nicol, another son-in-law of D. Orange, was the farmer at Crow Mill. The last farmer in the 1930s, when this picture was taken, was Jack Thornton. The area has now been covered by the modern houses off Mill Close.

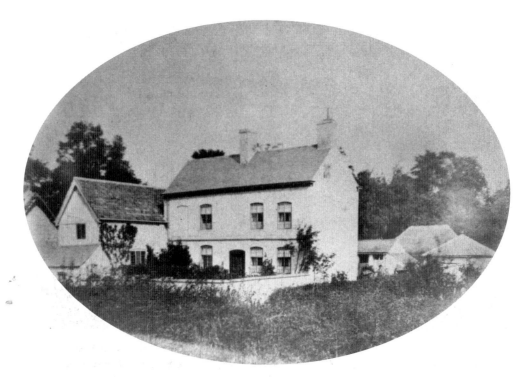

The property on the left with the gable end was an old farmhouse belonging to Wyggeston Hospital. It stood in Bull Head Street. During the 1920s it housed a farm manager and Albert G. Shipp lived next door at the main house, no. 86, known as Rowan House. In 1936 Thomas Norman Hill and family lived in the Wyggeston property and continued there until it was demolished to make way for Kelmarsh Avenue. Other occupants of Rowan House in the 1930/40s were Phillip J. Wacks and later a Mr Roberts. This house happily survives as a private home.

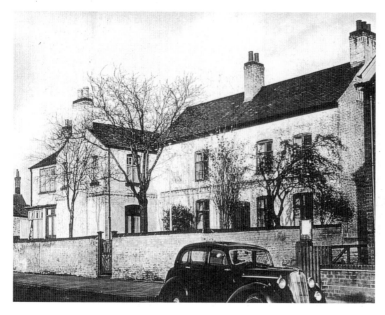

The same buildings taken in the 1950s. Rowan House is still much the same but the Wyggeston farmhouse has lost its thatch and has had an upper floor added.

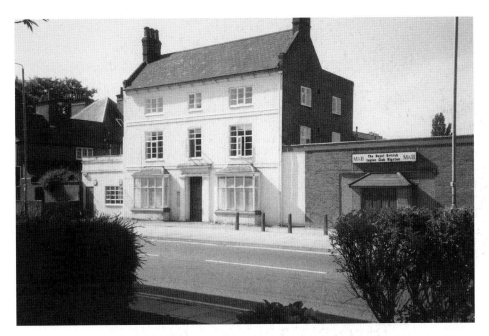

A recent photograph of The Elms, Bushloe End, which was built by Samuel Davenport in 1752, according to a tie-beam in the stables. By 1838 it was owned by Richard Seddon and remained in that family until about the 1890s. From about 1906 it was the home of John D. Broughton and then his son Bertram. During the Second World War it served as a billet for reservists and was eventually bought by the British Legion who saved the façade when doing extensive rebuilding at the rear.

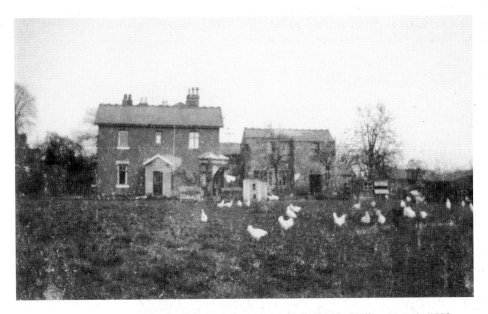

Yeoman's Cottage, Granville Road, seen from the rear. It was bought by William Yates in 1892, who ran it as a pig and poultry smallholding. In 1923 it was bought by the owners of Woodville, next door, who were not too keen on the pigs! It was enlarged and upgraded and a member of their family occupied it. It is now known as The Firs and is in private occupation.

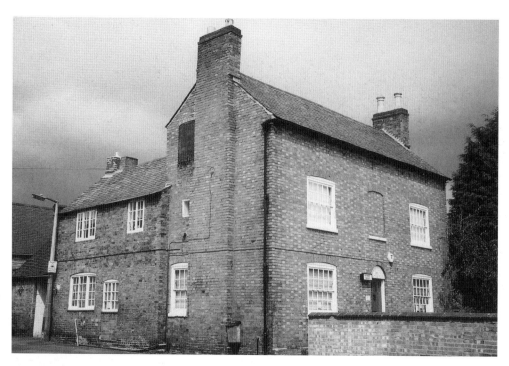

Fulwell Farmhouse, Long Street, seen in a modern photograph; another property built sideways to the road during the 1770s, with a smart Georgian front added later. The rear incorporated a brew house and the boarded window above second-floor level once had the sign 'Cheeseroom' above it. This designation of a room was in order to save tax. The house along with its land was bought by Wigston Co-operative Society in 1896 and thereafter known as Avenue House. The manager, John Wignall, lived there in the early twentieth century. It is now occupied by Bell, Brown & Bentley, veterinary surgeons.

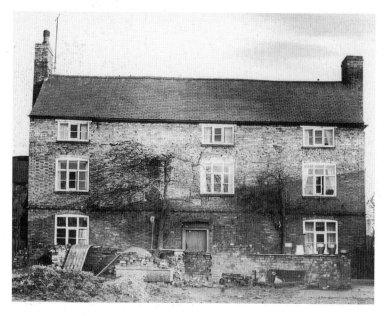

The Farmhouse, 10 Newgate End, pictured in the 1950s. It was built by John Pochin in 1691 on the rubble foundations of a previous building. The third floor was added in about 1800. It is thought to be the oldest surviving brick building in the area. By 1888 Daniel Johnson was the farmer and it continued as a working farm in the same family until the 1960s. It is now a private house.

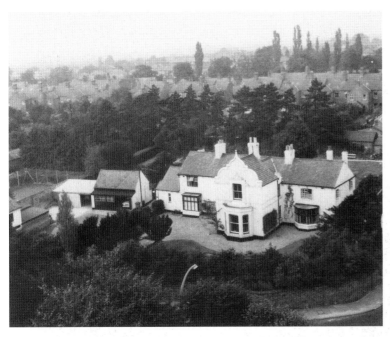

Kingswood Lodge, Long Street, shown in this 1960s shot taken from the All Saints Church tower. It has since lost the attractive gable. Possibly built around 1844 for Augustine Fry, surgeon, it was described in 1859 when sold by his widow as a residence or hunting box with 30 acres of land. It was bought and farmed by Robert J. Chambers. By 1908 it was the home of Dr A.N. Barnley, and by 1941 Dr G.W. Sturgess, to be followed by Dr Cowling. It is now a residential home, although the Bushloe End Surgery still occupies part of the site.

A modern photograph of The Cedars, Moat Street. The house was probably built by Edward Blunt, surgeon, who was in residence by 1803. Blunts Lane was so named because patients would walk along there to his surgery at the rear. It remained in the family until the late 1860s when, following the death of Blunt's son Thomas Edward, also a surgeon, the family left for Leicester and Blaby. For the next forty years it was the home of various high-ranking officers from the barracks. By 1925 it was the home and practice of Harry Durrad, a dentist. It continued as a private home until divided into three separate dwellings more recently.

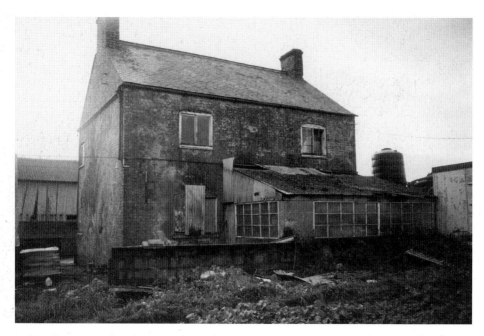

Glebe Farmhouse, Newton Lane, taken from the rear. It was built around 1864 but is now derelict, the farm run from an adjacent new bungalow. From 1766 the farm was Church property and run by tenants, but by 1930 it was in private hands and known as Wigston Lodge, before reverting back to the original name. Farmed since 1964 by the Pierce family, it was previously owned by Edgar Smart of Newton Harcourt and the house occupied by an employee.

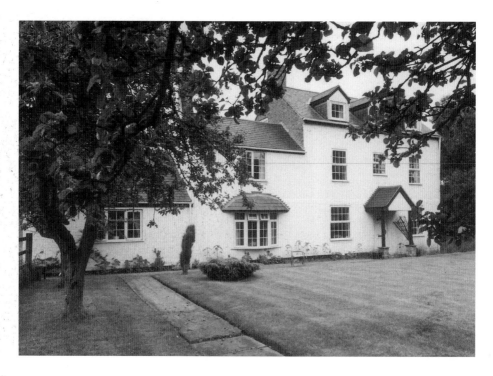

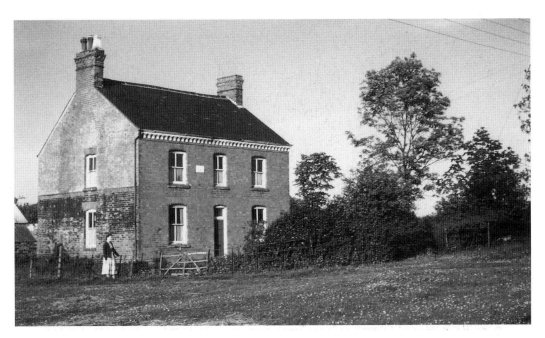

Highfield Farmhouse, Newton Lane, pictured in 1957/8 with Jean Bale outside. It was built in 1874 for a manufacturer believed to be named Johnson. From 1915 Walter Mason lived there and by 1930 it was Thomas William Kind. Other occupants are thought to be the Wilfords and in the 1940s the Harrisons. Farm worker Jack Holland was there before the Bale family, who remain there today. Before the Second World War the farmland was known as Lower Farm and formed part of one estate with Upper Farm (page 110).

*Right:* Squire's Knob Farmhouse, 5 Newgate End, during the 1950s. The name is thought to mean the knob, i.e. hill, belonging to the squire, in this case the Davenport family who probably owned this farm which was adjacent to their moated manor house to the south of Moat Street. Abraham Forryan bought the farm around 1802 and it remained in the same family for 150 years. The last farmer was Arnold Forryan. The house is now gone and the land forms part of Little Hill housing estate.

*Opposite below:* Modern photograph of Kilby Bridge Farmhouse, off Durnford Road, which is believed to date from the early 1800s. During the 1860s Michael Taylor was the farmer and his name lives on in Taylor's Bridge over the canal, and the road name in the development off Lansdowne Grove. His land stretched both sides of the canal and he would have used this bridge frequently. The house is now a private dwelling.

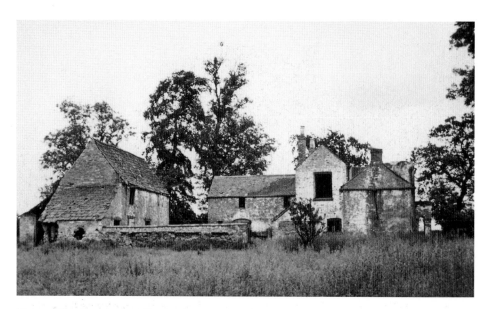

Tythorn Farmhouse, near Kilby Bridge, was situated in a remote spot near the canal overlooking Kilby; it never had a made-up access road. A semi-mansion built in the late eighteenth century, it had been home to generations of the Langham family who were prosperous farmers, largely due to supplying prime beef to the expanding London market. By 1964, the date of the photograph, it was condemned and then demolished by order of the council. The discovery of a Neolithic axe head nearby proves the age of the site.

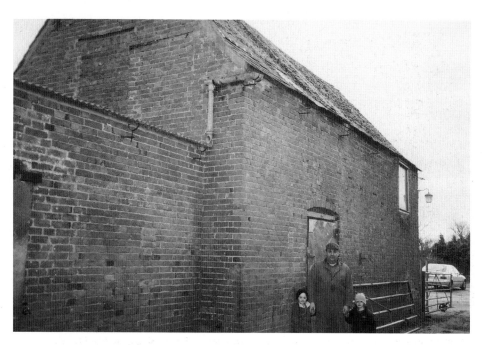

Cal Dobson's barn was once part of a small farm at the top of Cooks Lane and was later absorbed into Tythorn Farm. It is the only surviving working barn of the enclosure era (1766) left in Wigston. Pictured outside is farmer and contractor Ray Pierce with his two grand-daughters.

Modern photograph of Crow Mills, Countesthorpe Road. There has been milling on this site by the River Sence since the thirteenth century, the present building being constructed on original footings. Initially just water power was used but later steam as well. In 1863 there were three millers busy in the area: John Robinson worked the nearby windmill, Thomas Gist the Union mill and Thomas Townsend the steam mill. The property now makes a highly original private dwelling.

This old cottage with stables and outbuildings, together with another similar cottage and nearly 9 acres of meadow land called South Slade, were situated on the east side of Welford Road between the bridges at Kilby Bridge (page 18). All was sold by auction for £547 14s 0d at the King William IV Inn, Great Wigston, on 8 May 1890. The vendors were the children of the late W. Elliott of Shearsby and the property was let for £27 annually.

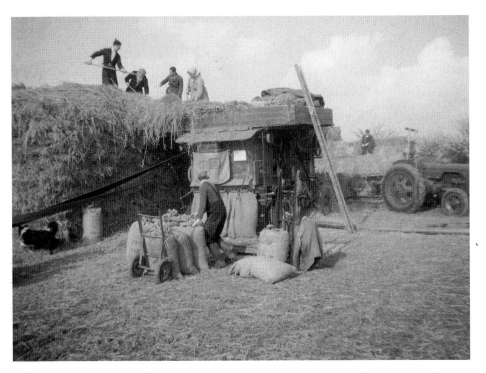

Harvesting 1950s style. Threshing (separating the wheat from the chaff) was hard, dusty work before the days of the combine harvester. Here Wilfred and Margaret Kind *née* Charles work on the stack while Jack Holland sits on the straw. The dog is no doubt looking for rats which were often disturbed as the stack was dismantled.

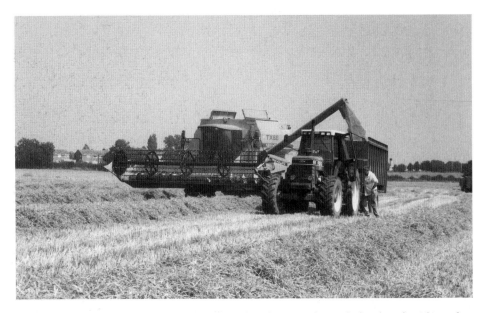

Harvesting in 2003 is a slick operation in comparison, but something of a lonely task with much of the comradeship gone. This scene was taken in fields to the north of Newton Lane.

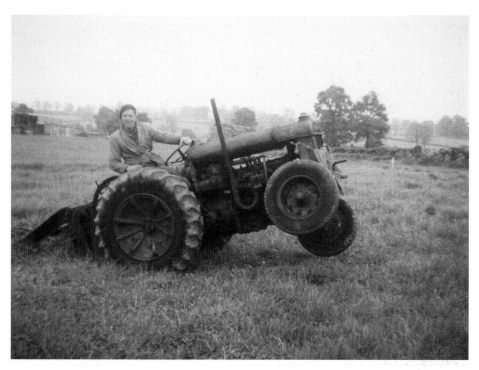

Wilfred Kind on his 'dancing' 1940s tractor. Power generated through a winch was the cause of the acrobatics. He was mole draining off Newton Lane in this 1980s picture.

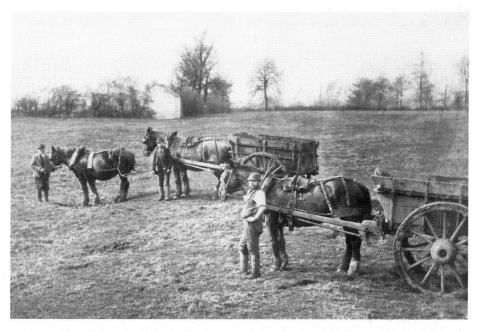

A lovely scene of bygone farming, believed to have been taken in the 1890s in Hanging Hill, a large field between the railway and the canal to the east of Crow Mill, behind Magna Road, and now developed by Wimpeys.

*Above left:* Keith Mould with his postman's bicycle in a recent photograph. The name Mould has been recorded in Wigston records since the 1377 Poll Tax.

*Above right:* This field to the south of Newton Lane was anciently known as Mould's Pen. The stream is Blackwell Sike and flows from the fields to the north of Newton Lane, through Ash Pole Spinney and under the road to emerge at this point.

Jean Lucas walking along The Meres, the old parish boundary between Wigston and Newton Harcourt. It starts at Newton Lane and emerges by the Glen Gorse Golf Club on Glen Road, Oadby. Each year there used to be a Rogation Procession when villagers would bless the crops and walk the boundaries of the parish so that their position would never be forgotten.

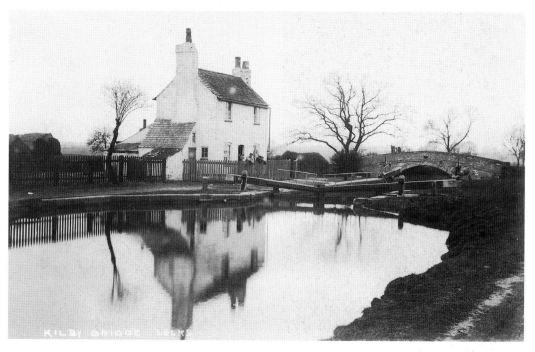

The little Lock Cottage which stood by Bridge No. 88 on the canal at Kilby Bridge. The Chapmans once lived there and the last family were the Mercers, who are now newsagents.

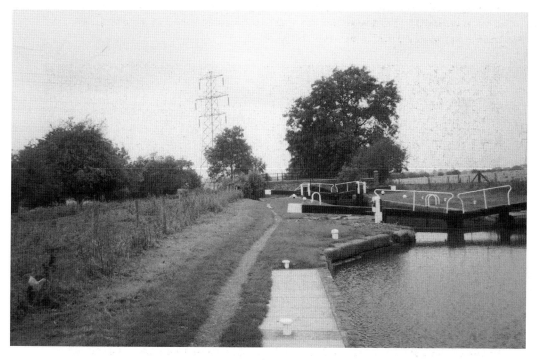

The same scene today minus cottage and plus electricity pylon. The place where the cottage stood can be determined by the uneven ground and stray pieces of masonry.

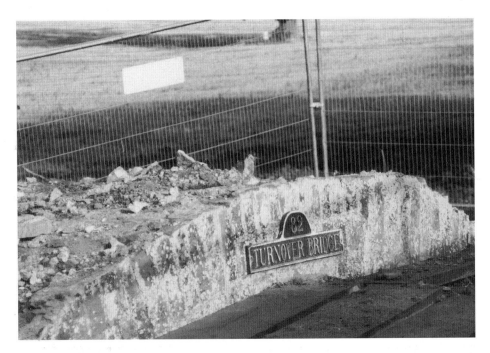

Turnover Bridge No. 82, near Kilby, was extensively repaired in 2002. The canal had to be drained for a time for this work. The towpath changes sides here and reverts back at the Wistow/Kibworth Road. It is said this was done to appease some landowners who did not want the towpath to be sited on their side of the canal.

Before the repair work started, local water traffic was warned of the dangerous bridge ahead.

Trials of the Midland Railway Company. Their Derby to Rugby line via Leicester and Wigston had to cross the canal and River Sence by viaduct. The line was opened on 30 June 1840. The viaduct spanned both water courses with timber trestles and with brick arches between. It collapsed five months later and was rebuilt, the miller having averted a terrible accident by running up the line to warn an approaching train. It partially collapsed again in September 1852 due to floodwater undermining the piers. This engraving of the time was featured in the *London Illustrated News*. It was reconstructed again and the timber trestles over the canal replaced with a metal bridge.

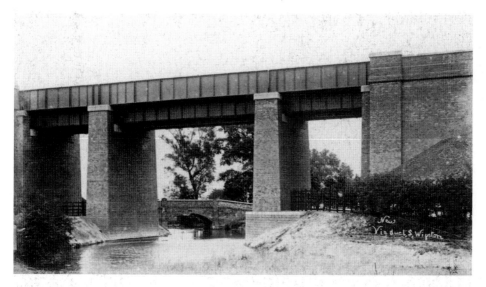

In 1912 after more extensive flooding, the brick arches were replaced by an earth embankment and the remaining trestles dismantled and replaced with this bridge, photographed the following year. The line became a 'Beeching' victim and was closed on 2 January 1961, the two railway bridges being subsequently demolished. All that remains now is the embankment which, from the top, gives a good view of the surrounding area of Crow Mills and the twin road bridges.

# Other local titles published by Tempus

## Leicester Voices

CYNTHIA BROWN

These personal memories of the past provide a valuable record of what life used to be like in Leicester. Each story illustrates a different aspect of life in the city as it once was. From memories of childhood and schooldays, work and family, war and peace, each piece offers an oral testimony into the lives of people who have lived in and known Leicester over the decades.

0 7524 2657 5

## Folklore of Leicestershire and Rutland

ROY PALMER

This book is a comprehensive survey, drawing on a wide range of printed, manuscript and oral material. The topics covered include local legend and lore, ghosts and witchcraft, folk medicine, work and play, sports and fairs, crime and punishment, music, drama and calendar customs. Among the many illustrations are documents and prints, archive and recent photographs, and over twenty music examples.

0 7524 2468 8

## Leicestershire County Cricket Club

DENNIS LAMBERT

Founded in 1879 and playing first-class games since 1894, Leicestershire County Cricket Club has a rich sporting heritage. This book brings the history of the club to life, with over 220 action shots, team groups, player portraits and other items of memorabilia. With expert captions from the club's official historian and statistician Dennis Lambert, this book will delight anyone with an interest in Leicestershire County Cricket Club or the history of the great game of cricket.

0 7524 1864 5

## Around Lutterworth: The Second Selection

GEOFF SMITH

This fascinating second selection of over 200 old photographs and images revisits the town of Lutterworth and also travels further afield to explore the surrounding villages using material from over two centuries. This valuable compilation explores all areas of everyday life, with trade and industry, schools, shops and businesses, celebrations and wartime all remembered.

0 7524 2480 7

If you are interested in purchasing other books published by Tempus, or in case you have difficulty finding any Tempus books in your local bookshop, you can also place orders directly through our website

www.tempus-publishing.com